In the Company of Sisters

Portraits and Reflections

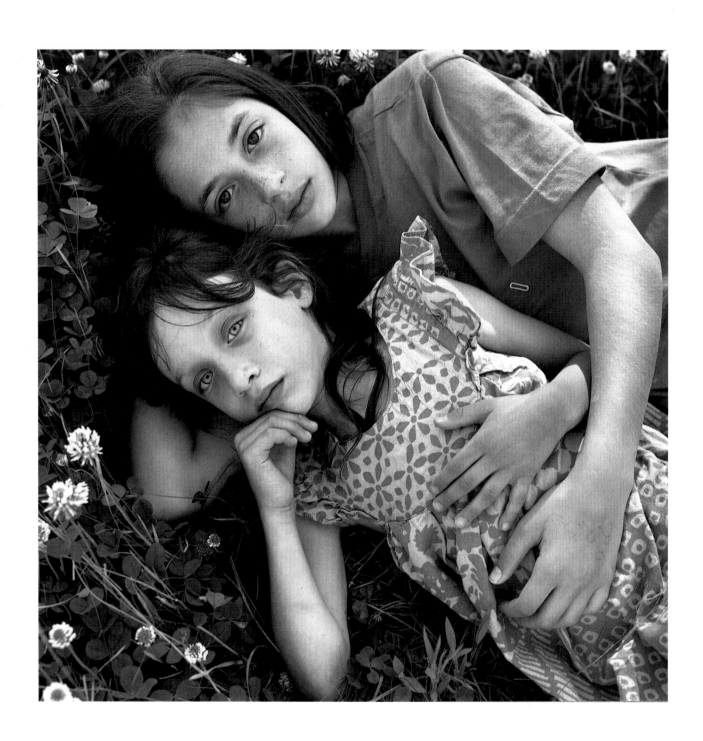

in the company
of sisters

Portraits and Reflections

Deborah E. Donnelley

Frontispiece: Sierra and Leila
Page 114 photo by Jean C. Farwell

ISBN 0-9743388-0-X

Produced by Kim Coventry, The Coventry Group, Chicago
Designed by The Grillo Group, Chicago
Separations by Professional Graphics, Inc., Rockford, Illinois
Printed and bound in Italy by Arti Grafiche Amilcare Pizzi

Published in Oak Park, Illinois
First edition

Contents

Foreword

I don't have a sister. In fact, when I was an only child of 11 and my mother announced her pregnancy, I hoped for a brother, dreading the seemingly endless fights over bathroom time, clothes, and friends that my girlfriends endured with their sisters. I promptly informed my mother that unless the baby was a boy, I would have to move out. Luckily for me, I ended up with a brother. As we've grown together, I've realized that it was not his gender that mattered as much as the simple fact of his existence: even though he isn't a girl, I still fight with him and love him and sometimes get jealous of him. These are all experiences that inhabit the territory of siblinghood.

Because I have a brother and not a sister, I enter into Deborah Donnelley's photographs through the lens of *being* a sister rather than *having* one. As I looked through the images for the first time, I realized that nearly every photograph and interview reinforced my own identity as an older sister. These photographs remind me of the sense of fulfillment I get from being a sister as opposed to the only child I was for eleven years. However, the photographs also make me question just how different my relationship with my brother would have been if he had turned out to be a girl. Would the similarities of our bodies have changed the way we felt about each other? Would we have formed a different kind of bond? I imagine that different questions will arise for every reader whether or not one is or has a brother or sister.

One aspect of siblinghood that has always amazed me, and what Donnelley's photographs constantly remind me, is that siblings are the only people to have occupied the same space inside the same mothers' bodies, to have absorbed life from their mothers through thin umbilical cords, to have such similar DNA. Even outside the mother's body (and this is especially true of siblings who do not have the same biological parents), siblings are bound together by the physical space of living quarters and the emotional space of family. While the shape of the physical space might be in constant flux, the emotional space remains intact. These photographs, within their square frames, point to that physical and emotional space of family and siblinghood that is so difficult to articulate. They describe those invisible tethers, the shared blood and/or histories, and the blurring of boundaries that happens among family members.

The photograph of Leila and Sierra in particular represents to me what it means to be a sister, particularly an older sister. Sierra and Leila lie in the grass, Sierra's hand draped across her sister as if to protect her. The older sister begins to blend into her younger sister, erasing boundaries between them, in order to shield her from some outside (potentially threatening) force. In both the photograph and the text, Sierra presents herself simultaneously as role model, confidante, friend, and protector. She seems to exist in the photograph specifically in relation to her younger sister, revealing few identity markers of her own other than the faded writing on her hand. While Sierra's face suggests understanding or protection, Leila looks unflinchingly into the camera, at once challenging the photographer and asserting herself in a way that her sister does not.

Donnelley's photographs chronicle the relationships between sisters of different generations, family compositions, cultural backgrounds, and age spans. While each set of sisters has a unique story, they all speak to an enduring characteristic common to siblings: a certain fundamental connection. Those of us who have siblings depend on them as sources of our identities, as mirrors to hold up to ourselves to remind us who we are. Though the photographs in this book depict specific people at specific times of their lives, there is something in every image and interview that will resonate with each of us, regardless of our individual situation.

Sara Lasser

Introduction

Complex Intimacies: The Images

I am the youngest of three sisters. Myra and Diana are five and four years older, respectively, than I am. When I was growing up, there was never any such thing as a life without them. It would have been impossible to separate my sisters—their voices, the way they moved and smelled, their warm skin—from what I understood to be my world.

In 1987, when I was 25, my sister Diana became a mother, and in 1988, Myra followed suit. As the youngest, I found it difficult to comprehend my sisters' shift into parenthood. I had never contended with the rude shock of displacement. We sisters were like a ring. Now that circle was disintegrating, reorganizing—and I was paddling after it. My defining sense of myself as a sister was falling away, and I was left with a terrible feeling of mute absence. I think of my original drive to photograph sisters as an attempt to mark, to name, and to claim something deeply held within me. Until the contours of our relationship changed, I did not understand that I had always known what it was to be a sister.

I made the majority of the photographs in this book between 1987 and 1992, when I was in my mid-20s. The beginning of the project coincided with my 1987 departure from New York City, where both of my sisters also lived, for a house in the woods in a small western Massachusetts town. My sense of leaving my family was intensified because I knew only a handful of people there and had only a vague sense of place. I ran an advertisement in the local paper looking for sisters willing to be photographed. I received a half-dozen responses; the remaining sisters came by word of mouth. By taking these photographs, in the company of these sisters, I came to locate myself in a particular place at a particular time. Each image was like a different sentence in a complicated love letter I was writing to my own sisters.

During the initial five years of the project, I photographed about 250 sets of sisters. From these, I selected about thirty for the core of my portfolio. Generally, I met with the sisters twice: During the first encounter I did not bring my camera; during the second, I usually photographed them for about an hour.

Many of the images were choreographed. I would ask the sisters to move closer together or further apart, and I would experiment with my own proximity to them. I waited for that moment when some complex intimacy would appear—a protective rebuff, a warm distance, a reluctant loyalty. What I wanted to reveal was not something that could happen with one sister alone, but rather *between* or *among* sisters. I wanted the chemistry.

Sisters over Time: The Interviews

At its start, I conceived of this project only in terms of images, even though I had several memorable, moving, and often hilarious conversations with the women and girls I photographed. I stopped photographing sisters in 1992. But it was not until eight years later, in 2000, that I decided to interview them.

In the interim, I had married, attended graduate school, and worked on other photography projects. In 1998 I moved back to the Chicago area, where I had lived until I was 13, and where both of my parents still lived. My husband and I had three children—a girl and two boys—and were contemplating a fourth, hoping for a sister for our daughter. Coming home filtered my childhood memories—the houses in which we grew up, the way my granny had said "southmore" instead of "sophomore," bare, leafless Novembers—through my adult experience, like a film overlay, at once transparent and tenaciously bonded. Our life as a ring of sisters, perhaps my most self-defining characteristic in those early years, also emerged in my consciousness, remembered and reconsidered from an adult perspective. What exactly was my relationship with my sisters now?

By moving to Chicago, I planted myself in the middle of the country, between my sisters. Facing east, I can follow the steady, chatty line of my relationship with

Diana, who lives in Connecticut. She and I stay current. We know the general outlines of each other's daily lives and speak regularly about children, husbands, and work. We have ongoing conversations about certain family subjects. I know each of us is thinking of the other. Facing west, I can trace a vaguer path to Myra in Oregon. Like following an unused path in the woods, I can go a distance and think I have lost the trail to her completely, only to chance upon a marker—one of her perspicacious insights, one of my stories that makes her laugh, an occasional burst of contact—that restores my sense of direction and connection to her.

The circle joining the three of us is gone, and surviving it are discrete relationships, each quite different in form and timbre. Nearly gone as well is that acute sense of absence, softened by time and the presence of other intimacies. And so, I wondered, what of the other sisters, those I had photographed? What had happened to their relationships? I realized I could, through interviews, glean something beyond the images I had taken: stories that would tell me something about *sisters over time.*

I was able to find most of the sisters depicted in the portfolio's thirty photographs. Some sisters declined to be interviewed. In four instances, I was unable to find the sisters; one subject, my great Aunt Jane, had passed away, and her sister, my grandmother Ann, was physically unable to participate. I conducted the rest as loosely structured, one-hour telephone interviews, which I tape-recorded. I added a few portraits that I made after my return to Chicago. Thus, unlike most of the interviews, which I gathered ten to fifteen years subsequent to the photographic sessions, the interviews with these sisters are approximately contemporary with their images.

I transcribed the interviews, edited them down to two to four pages, and then sent drafts to the sisters for editing and approval. Some felt more comfortable than others sharing the personal parts of their lives in print. Others chose to rewrite the interview themselves, either because it failed to convey what they had tried to say or because their lives had changed momentously and their stories needed updating. I then edited the text again, in some cases sacrificing for lack of space some of the rich detail, but preserving, I hope, the essence of their reflections about their sisters and themselves.

As I listened to the interviews with sisters within given families, I understood, as Denise, one of the sisters in the project, so aptly put it, that "between us is the whole record . . . the story of our family." Each individual interview could be seen as a piece of a larger family mosaic. At the same time, in the interviews, one could also intuit, as poet Adrienne Rich has stated, "what is not found there"—the missing pieces, the disconnects, the implications of later revisions.

Pivotal Moments: Pictures and Words Together

Stepping back and listening to the interviews as a whole group, I could see that in the arc of a relationship between sisters over time, there appear to be certain pivotal moments when sisters' connections to each other are pressed to the foreground, challenged, and ultimately, reconfigured. Author Elizabeth Fishel, in her powerful book *Sisters,* articulates this notion of a pattern of change common to many sisters at certain "stages" or "developmental periods." In the interviews for this book, most of the women highlighted central experiences: the moments when a sister is born, when sisters experience adolescence, when sisters make families of their own, when parents die, and when there is the loss—either actual or threatened—of a sister. At each juncture, sisterly routines, roles, and power dynamics shift, sometimes subtly, sometimes precipitously. Many of the narratives richly depict both the excitement of emergent relational possibilities and a concurrent sense of loss as the sisters navigate these periods of flux. There are a number of sisters, too, who seem to pass through these periods without significant disturbance. These sisters describe their relationship as deepening gradually, whether by the simple circumstance of day-to-day contact or by the powerful pull of a shared history. Whether warm or distant, conflicting or peaceable, common to all of the relationships here was an earnest desire to be close to each other.

The pivotal moments created a context in which I could consider the dialogue between the photographs and the later text. As I move back and forth between the photographs and the text, I am reminded of the inevitability of change in relationships between sisters, and of how "being" a sister is often about "choosing" to sister. I can begin to place my personal sister narrative within the constellation of these other stories, and I can offer both of my daughters, as they find their way together, images in which they may find themselves reflected. And, thankfully, I find myself more fully in the company of sisters.

Deborah E. Donnelley

For my sisters

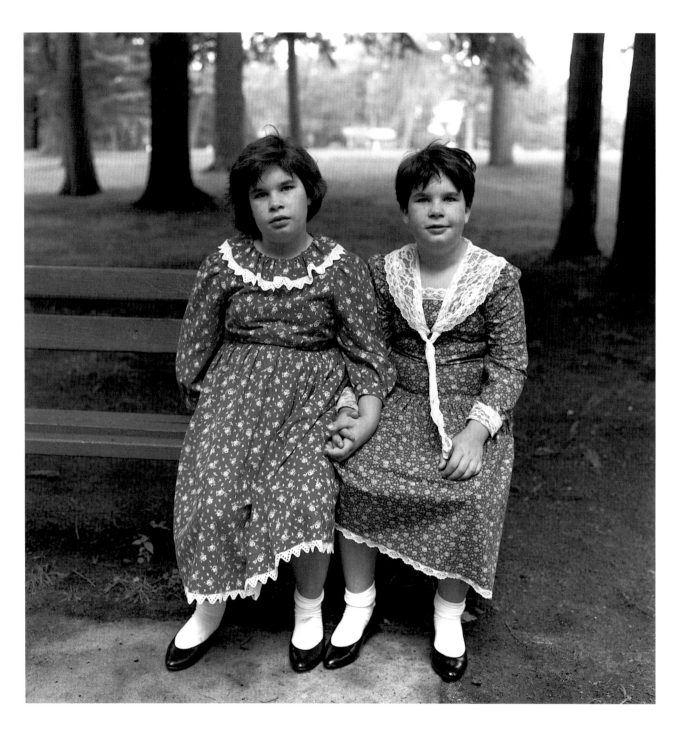

Moriah, age 8 Isabel, age 8

moriah isabel

Moriah, age 22. Our parents never told us who's the older sister, and they still won't. It wouldn't make any difference because we're so close as twins. Our parents always allowed us to make our own decisions and we grew up figuring out the consequences as they came.

During high school, my mom taught half the week in Boston, and my father worked in Maine. Iss and I stayed in Amherst because the schools were better. Although our parents were accessible, Iss and I were on our own quite early. We weren't troublemakers. We were directed then, and we still are.

Initially, in college, Iss was interested in law and I in science. Eventually, however, we independently came to the conclusion that we wanted to return to theater. Now, we're in graduate school studying set design. I don't know if our career aspirations have to do with us being twins, but it might help us out later on. It certainly has an impact.

We're often treated as an oddity. People sometimes find the twin thing funny or charming. Others compare us as if we should be the same person. Or they'll ask ridiculous questions like, "If your twin gets hit, will you feel it?" I'll get annoyed, whereas Isabel is more likely to laugh it off.

Some people tell us we're really different, but I don't see it. Yes, she's more social than I am, but I feel the similarities so much more—our values and goals, our taste in music and clothing. If I'm freaking out about something, she can shed rational understanding on the situation because she's shared so many similar experiences. Iss can always tell me the right thing. I don't always know where other people are coming from.

We know other twins who aren't very close. They find what they dislike about themselves in the other. We don't really do that. Most of the time, we manage to not get on each other's nerves. Sometimes it happens. But it's family so it blows over. We're closer than friends. We've always been together.

Isabel, age 22. Growing up as twins, we never felt that we had to be the same. My parents were smart enough to let us be. We were never forced into dressing alike or doing the same thing.

Both our parents were working elsewhere while we were in high school, so Moriah and I were sort of parenting ourselves. We'd share our problems with each other because we're twins and we analyze things more deeply. We were shy bookworm types, and arguing wasn't much in our temperament. We spent a lot of time together unmediated by whatever was going on with our parents. We grew really comfortable with each other.

Early in college, we were studying different subjects, which gave us separate experiences to relate to. Eventually, though, we started moving in the same direction—theater. We tried not to do the exact same thing, but it soon became, "Well, why fight it?"

People always project their own expectations on us, wanting us to be either the same or opposite. How do we explain to others that we've had the same experiences, so we often share perspectives and/or come to similar conclusions? Their need to constantly remind us that we're twins is annoying.

With friends you need to explain things. We don't. Our relationship exists more on a nonverbal plane. Once we were mixing paint for a set, and we didn't have the right color. I would add blue and she'd add black without ever saying a word. It's like we complete things for each other. We've known each other for so long, and we're so much a part of each other's lives. We try hard not to exclude people, but when they want what we have with each other, it doesn't happen. It's just not possible.

I just assume Moriah's presence. I'll be alone and I'll start talking as if she were there because I forget that she's not there. My friends often say, "You're talking to yourself again," and I say, "No, I'm not. I'm talking to Moriah, damn it! She's just not here." It's the closest friendship I can ever imagine.

With friends you need to explain things. We don't. Our relationship exists more on a nonverbal plane.

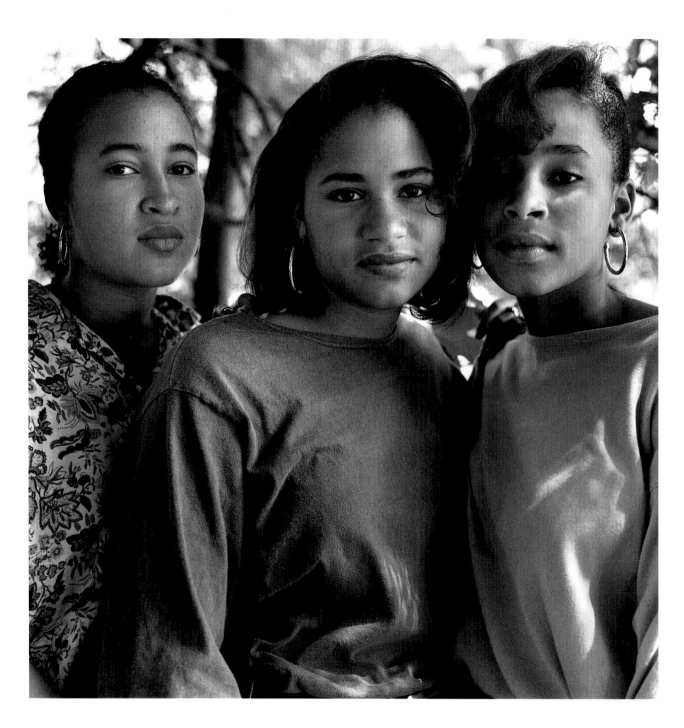

Kiki, age 18 Ify, age 15 Ekene, age 14

kiki
ify
ekene

Ify, age 26. Our formative years, particularly mine, were spent in Nigeria. My dad worked as a professor in the small capital city of Enugu, a largely civil-servant town with several universities. We returned with my mother to the States when I was 6. My parents had separated, and shortly thereafter got a divorce. That transition was really difficult and it significantly shaped our personalities. Looking back, we realize that it was the very challenges of being biracial and bicultural that created a platform for us to connect as sisters. As we later came to appreciate, it formed a sense of unity and mutual support among us.

Upon returning to the States, we moved near my grandmother in Connecticut. The climate was very different, and the town was very white and privileged. There were only a few other Black families. At that point, my parents were still hoping that they could work things out, but they were unable to. Unknowingly, we had left Nigeria for good. We were all experiencing internal anxieties that we couldn't name or articulate because we were so young. Two years later, we moved to Amherst, which was much more liberal and where there were other people of color.

We saw very little of my father after we left Nigeria, since it was so expensive to travel back and forth. We communicated mainly by letters and an occasional phone call. There was no one acting as a father figure for us here, and I felt a certain vulnerability, as if we were "deserted females." We eventually developed a sense of ourselves as four women trying to hold it together and succeeded in doing so. The absence of a male figure in our daily lives ultimately made us stronger, both individually and as a group. We relied on each other.

Each of us had a different relationship with my father and had spent some time alone with him over summer vacations. Then, in 1992, we all went together for the first time, and it was really powerful. My father had since remarried and we had younger half-siblings in Nigeria. We sisters were comparing notes and trying to make sense of our understanding of our culture, of what Nigeria meant to us as young adults, and of what kind of relationship we wanted to have with my dad and our new half-siblings.

We came together again as sisters with my father's death in 1994. A couple of months after we first found out he had prostate cancer, he passed away. We were confused and scared. We had talked on the phone before he died, but we never got a chance to say a real goodbye.

The funeral was the first time we had been in Nigeria without my dad. On top of the grief and loss we were experiencing, we were anxious about how we would continue our roles in that society without his guidance. Fortunately, our mother, who has retained a strong relationship with Nigeria, was with us and her presence made the experience much more bearable. My father's death was a big turning point for us in terms of knowing what type of relationship we wanted with Nigeria and how much effort would now be required to remain connected. My dad was always the link—to our culture, to our Nigerian relations, knowing where to go, even how to behave. Without him, we felt lost and afraid. I needed to reclaim Nigeria on my own terms, so I spent a year there, working and reconnecting with relatives, but I doubt I will ever live there again.

In Nigerian culture, there's a lot of emphasis on the responsibilities of the eldest child. You set the example for your siblings. Kiki has shouldered more of the responsibility than we realized to make money and to help support our family, like our father did. She has followed more the "straight path" in terms of her education and career in corporate law, although this is changing. I see her recent explorations as an act of reclamation of the bright, shining, center-stage girl she was in Nigeria. She is beautiful, sensitive, determined and introspective. I see her taking risks and becoming more authentically herself in so many wonderful ways.

We came together again as sisters with my father's death in 1994.

5

Ekene has expressed herself most as the artist, the musician. Funny, insightful, and animated, she's sort of a drama queen. She seems really comfortable with her body, who she is, everything about her, though at times, Ekene has felt pressure to live up to the examples that we set.

As the middle sister, I feel like I bridge the age gap between Kiki and Ekene. In the past, I've been able to connect with each of them. There's a spirit of independence, and at times being the odd one out, that comes with being a middle child. My interest in international development and African affairs has taken me a bit off the track but I still follow a discernable career path. I take a lot of risks and go for what I want. I'm making my own mark.

Although we're very different people, we share some commonalities. We've always had a strong work ethic and have taken academics seriously, a legacy of my father. We always had the highest expectations for ourselves. We also share a belief in the power of love, the goodness of humanity, and the beauty and creativity inherent in life—attributes that come from my mom.

The depth and tenderness of our experiences have solidified our bond. There just aren't many people like us in terms of our biological and cultural makeup. There aren't many people with similar experiences from whom we can seek support and understanding. That thing that makes us feel like sisters is both something that is and something that we actively work on. I've found my salvation with my family and sisters. I don't know what I'd do without them.

Kiki, age 29. We are three sisters—me, Ify, and Ekene. Our mother is white American and our father was Nigerian. I was born in Amherst, Massachusetts, and then, when I was 4 and Ify was 1, we moved to Nigeria. I have great memories of living there . . . of friends, of being outside all day long. Back then, I was really bossy toward Ify. Seniority, in the Nigerian culture, brings authority. Of course, my mom didn't buy into that concept, but outside the house, I acted like all my peers. Ify and I were part of a mob of kids. I didn't take her too seriously, but we played together a lot.

When I was 10, my parents separated, and we moved with my mother to Connecticut. At first, Salisbury seemed like a fun fairyland. But soon I became unhappy. Culturally, Salisbury is the opposite of Nigeria. There's no one on the street. It's all white. While Ify no doubt had a difficult time, too, it seemed she was able to integrate into Salisbury with relative ease . . . whereas I experienced myself as deeply "different" among a crowd of similar people, and that perception grew into my identity. Also, we slowly realized that the separation between my parents was permanent and that my father would not be there anymore. He was an essential person in my life,

and he just dropped out of it. He would write letters, but the distance and the expense made it really difficult for us to see each other. We only saw my father on four short visits after that. My mom often tried to talk about it with us, but we didn't talk about it much together as sisters.

Three years later, we moved back to Amherst. I was terribly anxious about being in a new place, with new people and not much money. I struggled with depression throughout my high school years. My sisters did not seem to be going through any of that, and I felt quite distant from them emotionally. I both scoffed at Ify and kind of envied her.

Ify and I were opposites in high school. I was angst-ridden and took whatever drugs I could find. I drank coffee and smoked cigarettes. I didn't see myself as even on the popularity food chain. I felt like an outsider, and I fulfilled this image of myself. I was reading all sorts of depressing books and listening to gloomy music. I felt that I was worldly now, and I could never talk about anything with my kid sisters, who knew nothing about the truth of life. It was a very tortured adolescence.

Ify, on the other hand, was kind of preppy, and she graduated from high school with lots of academic distinctions. She was captain of the track team. She also earned a great scholarship to college. I was proud of her, but sadly, I was still critical at times. Nevertheless, our mutual desire for academic achievement was one area where we identified with each other.

Ekene had just started to be on my radar. She had always been a meek child and I hardly noticed her. Then, in junior high, her whole personality developed into something very different. Some of her creative talents emerged. She became graceful, poised, and outgoing. She had a whole different energy, and since then, I've been interested in her life.

I took a year off after high school and then ended up in New York, at Columbia, majoring in African American studies and African studies. My sisters got used to having me out of the house, and that might have been what changed our relationship for the better. I started seeing them more as equals, as having a mind-space closer to mine. That's when we started to talk about my parents splitting up.

One of the most significant experiences for us as sisters was our dad's death. He was teaching in Hong Kong when he was diagnosed in '93 with advanced prostate cancer. We were going to visit him in Hong Kong, but he kept telling us to wait until he made it back to Nigeria. There wasn't enough time. He died a couple of months later.

During the funeral, we stayed in the retirement house he was building in the village. The house was never finished. Funerals in Nigeria are kind of a raucous celebration—a huge gathering of people, lots of food, dancers, wailers—all in honor of the person who died.

The depth and tenderness of our experiences have solidified our bond. There just aren't many people like us in terms of our biological and cultural makeup.

It's rather jarring if you're the bereaved and needing peace. As the grieving daughters, we were expected to dance around the compound with his portrait. I found the funeral very moving and painful. It was a deeply felt experience that the three of us shared.

My father had always been my link to Nigeria. He was the translator, and now that's gone. To me, Nigeria is a place where I will go from time to time to visit with family, but I can't see myself living there again. I feel both bitter and accepting about the loss of Nigeria in my life.

People sometimes only see our similarities as sisters, but I see us as really different women with different strengths. I know I'll never disconnect from my sisters. Not that we're perfect together. We still say and do things that hurt the others, but we always deal with it, eventually. There's still a sisterly aspect in the way we take each other for granted, even ignore each other for periods of time—something you can't do with friends. Because of logistics, it's hard for us all to get together, but we really do generate this energy. We feel really good together, and we like it. We feel complete.

Ekene, age 25. I was born in Nigeria and lived there until I was three. I don't remember too much about our life there. When I was nearly 4, my mother moved with the three of us near her family in Salisbury, Connecticut, because my parents' marriage was basically dissolving. I was a little too young to understand exactly what was going on, but my sisters, who were older, experienced a more conscious break with our family in Nigeria—my older sister, Kiki, especially.

Kiki had a pretty idyllic childhood in Nigeria. She was the smartest, most popular kid in her class, year after year, and then, boom—we moved. There were no people of color, period—forget Nigerian. Suddenly, she was the outsider. She experienced intense isolation in such a lily-white environment, but at home we still had fun as sisters. We'd bang on the piano and fight like normal kids, but underneath there was a lot more going on. My mom was struggling to recover from a painful separation. Just by virtue of being older, Kiki was forced to confront my parents' separation much more than we did. My father came to see us several months after we arrived. Basically, he had been sent by our extended family in Nigeria to come and get us, but it didn't work out. A year or so later, my parents divorced, and I didn't see him for four years.

When I was in third grade, we moved to Amherst, Massachusetts, which was a better place for us. There were more people of color, more people socially and politically conscious about race issues and mixed kids. I saw myself reflected in the environment.

As a young girl, I had always been kind of shy—the baby sister. Then I hit my teenage years, and wow! Pow!

Out of the box! Both of my sisters left home when I was in eighth grade to attend private school and college. I experienced both a major loss of stability and newfound freedoms. I had a lot more room to both open up and act up, and my body was exploding. I had boobs! I felt pretty for the first time. It was really an experimental time in my life, and that affected my emotions and my grades, both of which went up and down. For the first time, I was seen as a young black girl—this was African American we're talking about, not Nigerian—and the cute black boys were paying attention to me. I began to consciously explore my black female identity.

My sisters weren't there to keep an eye on me or check me, but they were very good to me. They loved me and supported me, and I loved them. When I got my period for the first time, Kiki smiled and said to me, "Welcome to your womanhood."

In 1992, the three of us traveled to Nigeria together for the first time. We were going back to our home to spend a whole summer with our father. All the things we reexperienced! Our family members, the food, the culture, the private jokes. We got to know each other so well, and since then, my sisters have been my best friends.

I returned to Nigeria the following summer to be with my father, this time by myself. My strongest and best memories of my father are from that visit. It was a time of love and bonding that I will always cherish. I left in August, and the following January my father died of cancer.

The three of us traveled back again to Nigeria for the funeral for a month, this time with my mother. The experience was both beautiful and difficult. My father was considered one of the more important people in our village, and the funeral was a huge production. My sisters and I were cast into these roles of the bereaved daughters, and we were expected to perform a lot of ceremonial rituals. We stayed together in one bedroom in the back of his unfinished house, where we would receive visitors occasionally. That room was our refuge. That's where we'd cry and talk about things. That's where we'd eat if we didn't want to be bothered. Being in that room together fostered even deeper trust and intimacy between us. When we came back, our lives had changed forever. Our dad was gone. We continued being each other's primary support system throughout the grieving period, as we are to this day. As the circle got smaller, the circle got tighter.

We didn't have much money growing up, but we had a lot of love, and I love my sisters more than life. God has blessed me with my sisters. I *know* that I think about them every day and look forward to the times when it's just us three hanging out, drinking some wine and talking. My sisters are my hearts, and it will always be that way. It is very hard to imagine life without them.

People sometimes only see our similarities as sisters, but I see us as really different women with different strengths.

At home we still had fun as sisters. We'd bang on the piano and fight like normal kids, but underneath there was a lot more going on.

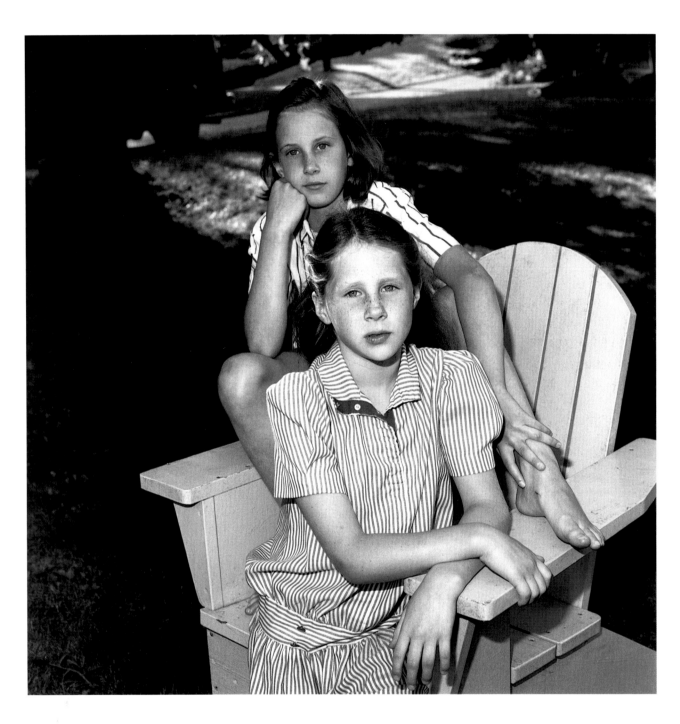

Margaret, age 12 Rebecca, age 8

margaret
rebecca

Margaret, age 22. When I was 12, Rebecca was 8. We lived out of town and spent hours playing very involved imaginary games. One game was "sisters lost in the wilderness." In those games, we didn't have parents or enough clothing. We'd bring baskets of food and ration it out down by the creek. We'd have costumes and props. The game would last the entire day, inside and outside the house. I think we enjoyed pretending to suffer.

I love the role of older sister. When I was 12, it meant that Rebecca would ask me questions and I'd answer. And she was always a little more interested in me than I was in her. I was responsible and serious, the one in charge. Rebecca was fiercely independent, stubborn, and a daredevil. We'd both climb the two big sugar maples in our yard, but she would always climb farther and higher.

Though we always knew that we loved each other, we fought a lot back then. We were argumentative and self-assured, and we hit, screamed, slammed doors, and said terrible things to each other. When we were old enough to stop bickering over who'd wear the pink dress, we discovered how close we had become.

Rebecca entered high school the same year I entered college. It was the first time we'd *really* been apart, and I don't think we expected that we'd miss each other as much as we did. We'd call regularly. We still talk late into the night when we have the chance. When we're at home, we're always together.

If you saw us now, you wouldn't necessarily know that I am the older sister. A real athlete, she's almost two inches taller and much stronger. I think of us as peers. I'm not quite as protective of her. I feel so lucky and proud to have been able to watch her grow.

We still get angry with each other, but we know it's nothing irreparable. With friends I'm more careful, but Rebecca's my sister. We can be annoying or silly with each other. We see eye to eye on so many things—political issues, literature, movies. And when I have something to share—a funny story, an opinion, she's the one I think of…like a reflex. I carry her with me all the time. My mother has this saying, "globally with you." Rebecca's always globally with me.

Rebecca, age 18. My goal since childhood has been to be taller than my sister, Margaret. When this picture was taken, I was 8 and she was 12. How tall, pretty, and grown up she was. I was loud, rambunctious, and annoying . . . a real tomboy. I won all the wrestling matches.

Back then, we lived in an old farmhouse. We were each other's constant companions, often to her chagrin. I was acutely aware that she had more privileges and responsibilities. Margaret was always in charge . . . not that I was easy to boss around. Being the younger sister gives you that sidekick aura, but I used that to my advantage whenever I could.

Later, I looked up to her like nothing else. I was always amazed by how smart she was, how much she could do, and how nice her friends were. Imagine how privileged I felt when she'd say, "Oh, my friends like you. Join us." Or when she'd kiss me on the cheek in the hallway at school. When she went away to college, it felt really empty without her in the house. We'd always been together. I was relieved when she said she missed me, too.

I never need to explain myself to Margaret. She knows me intuitively. She's always telling me that she's proud of me and that I'm strong. We have separate interests, but I deeply admire her kindness, her style, and her accomplishments. Now, at 22, Margaret's an aspiring soprano, and I'm sure she'll make it.

Some of my friendships have the same unconditional qualities that I share with Margaret, but they're still missing that other intangible thing. Other people don't share the same family history, the same family jokes. They don't understand our family's private language. Margaret's still very slender, but she's shorter than I am . . . by two whole inches.

When we were old enough to stop bickering over who'd wear the pink dress, we discovered how close we had become.

9

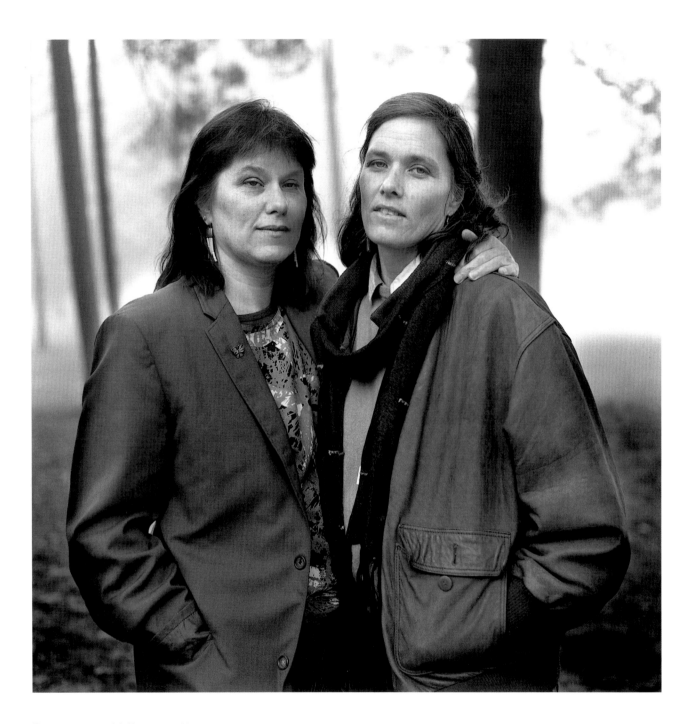

Susan, age 44 Melissa, age 41

susan
melissa

Susan, age 57. When it came time to write my text for this book, my mind began to spin with all of the potential perspectives from which to approach the wonderfully complex issue of sisterhood with my dearest younger sister, Melissa. How much history should I include? What about my older sister, Diane, and my brother, Phillip? I was mulling over the complexities of family dynamics—what changes and what remains the same among sisters over a life? What do I make of the subtleties and the innumerable memories—warm, funny, and sad? And then how do we integrate the profound and primal loss of my mother, who died several years after this photograph was taken?

And so I'll start at the beginning, at least *my* beginning. We were four children, three girls and a boy, growing up during the fifties in the Midwest. Born in 1946, four years after my older sister, Diane, I had some serious problems with my eyes, which precipitated many visits to eye doctors and a series of traumatizing eye operations. As this was an early challenge for me, it also made things difficult for my older sister, and then Melissa, since it demanded extra attention from my mother, father, and grandparents.

Recently, I was sitting with friends passing a Saturday evening talking about the state of the world, and someone commented that the three of us women were lined up on the couch, all sitting in a similar position, legs crossed, hands in laps—and I was in the middle. We laughed, but something in me flashed on a very deep and familiar sense of self—three girls lined up—the Tefft girls, with all the expectations of that conservative fifties family where girls were meant to look pretty, be polite, grow up, flatter and marry men with money, and have children—end of story. The Tefft girls. The adhesive that held this sense of self together back then was very sticky and tenacious. It took many years and my relocating first to Wisconsin and then Massachusetts for me to unstick that glue.

Back in those fifties, when we were little girls, Melissa and I shared a room. I remember finding Missie asleep, magically curled up in my doll's bed. We were even sometimes dressed in matching clothes. One blue summer play suit I remember particularly well. It must have been an enormously happy summer for me, when all was warm and safe in our world. Needless to say, life was not always like that.

In high school, Melissa and I took to walking after dinner and talking, talking, talking. We covered everything from our own family difficulties to boys and clothes and contemplating the meaning of life and how we were meant to fit into this world we were dropped into. I remember one time, during a strong summer rain, playing, soaking wet, in the puddles—laughing hysterically, and imitating Charlton Heston as Moses in *The Ten Commandments* as we stood on a hill overlooking a small ravine in our yard. Now those were good times.

When Missie was in college in Missouri and I was in Boston, we shared an apartment for one gloriously wild and woolly summer. This was 1971. We had a blast in a way that only sisters can. We supported and protected each other at this time of amazing experimentation and stretching what we knew of ourselves into the world around us.

When Melissa moved here to Massachusetts, she was quite sick and initially needed lots of help. She stayed with me for a while and then found her own place and friends. Then came the big challenge of figuring out how we were similar and different and how to carry our relationship into adulthood.

In the beginning, it was fabulous to have Melissa here. But then it became a struggle for the both of us. Were we too close? Too alike? Not enough alike? Did we still even like each other? We had to sort out our separate identities and carve out our own lives in this same small town. Lots of old sibling stuff began to emerge—competition that had never been addressed in the past.

We supported and protected each other at this time of amazing experimentation and stretching what we knew of ourselves into the world around us.

Something in me flashed on a very deep and familiar sense of self—three girls lined up—the Tefft girls.

In so many ways we are similar. We have a very similar political perspective and carry what we were exposed to in the sixties and seventies with us still. We both work as psychotherapists and want to make our world a little better than we have found it.

We are also quite different. Our paces are very dissimilar. Melissa moves very fast and I move more slowly. I believe we accentuate that difference in the presence of each other. Although we share many mannerisms, our physical appearance is quite different. We are both fundamentally kind, but sometimes I can be more abrupt on the surface. Neither of us has any children and I regret that. I believe I'll struggle with that for the rest of my life. No Tefft sisters in the next generation.

Our family is now dispersed all over—my brother in London; older sister, Dad, and his new wife in Ohio; and then, of course, Melissa and I here in western Massachusetts. Last summer, we spent time in northern Michigan at our old childhood vacation haunt. We blessed and scattered my mother's ashes in Glen Lake and celebrated her life and ours laughing and playing in the lake together. Over the course of the next week, I came to see more of Mother in each of us—mixed in with our own strengths and foibles. Family dynamics are wonderfully fascinating and rich. I love that Melissa and I live just ten miles from each other and that we spend holidays together and talk and have lunch as often as possible in our present-day demanding lives. And I know that we will always be right there for each other in times of need.

Every time there is a major change in the family, old sibling dynamics pop up. They shift and change, but the core remains the same. I think we'll still play out some of those childhood ways of being together when we're 90, but in a much gentler way, with more loving-kindness.

Melissa, age 53. Our happiest times together as a family were in northern Michigan, in our grandfather's cottage on the edge of a crystal-clear sand-bottom lake. We arrived every summer for two or three weeks to bask in the sun and have family time together. My memories swirl with images of skinny-dipping with my sisters and mother, and water-skiing, boating, and sailing. We had endless afternoons of being in and around the water. On rainy days we played card games, honeymoon bridge . . . listened to big band music, and shopped in the village nearby. My sisters taught me how to drive when I was 15 on an old Willys Jeep that my uncle salvaged from a junkyard after the war. Life was easy and fun and filled with family.

We were mother, father, and four children—three girls and a baby boy. Diane, seven years my senior, was not a playmate growing up, but more of a distant, beautiful role model. She had the sharpest memory, the most fashionable clothes, many of which she made, and the

air of being the eldest, which kept us in line. We have become much closer friends as adults and now share our work and life stories. Susan and I were only three years apart and were together often, particularly in our teen years. We lived in a great neighborhood full of children my age and younger. My brother and I were always off playing baseball, basketball, and group games. I was a real tomboy and looked to my sisters for hot tips on growing up. When Susan and I were in high school, we had a regular walking route through the neighborhood streets lined with crabapple trees. In the spring, we would walk in the evening, soaking in the fragrance and beauty of those gorgeous rose-colored blossoms as we laughed and shared stories of family and friends, and our hopes and dreams. We were confidantes then. It was so good to have older sisters to guide the way.

Susan moved to Boston after college and I moved to Ontario, Canada. We talked on the telephone regularly and visited often. In 1981, I moved from Thunder Bay to western Massachusetts. I chose this area because of its beauty, the arts and healing opportunities, and, of course, to be near my sister. During the transition, I developed an acute kidney infection and was quite ill. Both my sisters were incredibly supportive, along with my parents. While I was in Ohio recuperating, Diane visited regularly, took me on jaunts to the countryside, and as my strength returned, helped me in defining the new direction in my life. When I moved to Massachusetts, Susan was wonderful and helped me find an apartment, introduced me to all her friends, and was incredibly supportive of my healing process. I was so grateful to family during such a difficult transition in my life.

As Susan and I began to live so close to each other, we would have strong times of connection and sharing and then suddenly run headlong into old family issues that would mire us in conflict. When we were growing up, there were many confusing and troublesome dynamics in our family, and we came to rely on each other for comfort and reality checks. As adults, we were struggling to redefine our relationship, to know we could depend on each other even as we were independent. We needed to learn in a different way how to respect each other's uniqueness and strengths. Because we are sisters and committed to our relationship, we have shown each other our best and our most vulnerable sides—and stayed connected to tell the tales. We still don't always get it right, but the commitment to the relationship keeps us teaching each other more about being loving to ourselves and each other, and about being resilient. We can still be serious and also laugh ourselves silly. We have so much in common with our work and our lives, connecting can be such a rich treat.

In the 1990s our mother developed congestive heart failure. As the illness progressed over ten years, she

My memories swirl with images of skinny-dipping with my sisters and mother, and water-skiing, boating, and sailing.

We have shown each other our best and our most vulnerable sides—and stayed connected to tell the tales.

needed more care and more attention. I was so grateful to share this with my sisters and brother. Diane lived in the same community and worked hard to keep tabs on things, and find the right balance between being helpful and supportive of our mother and respecting her independence. I visited often, bringing a different perspective, living with my parents for long weekends. Susan and Phillip also visited often. We were able to share this experience as brother and sisters beyond our differences and it connected us in a deeply meaningful way. When our mother died in August 2000, I think we all felt we had given our best. We continue to communicate and be connected to each other and also to our father.

So when I think of sisters, my heart and mind of memory stretch over the years and I feel deep gratitude to be part of a family—to see that even in our uniqueness and difference, we have found ways to continue to be connected, learn from each other, and laugh and be there for each other in the celebrations and challenges of life.

This past summer we gathered as a whole family at our beloved northern Michigan lake to lay our mother's ashes to rest. We cried and we laughed. We sang songs and sat around an open fire by the lake and watched the sunset, eating s'mores. I felt the lightness of childhood in my bones and the ease of a long summer day. It was very precious to share this again with family after so many years.

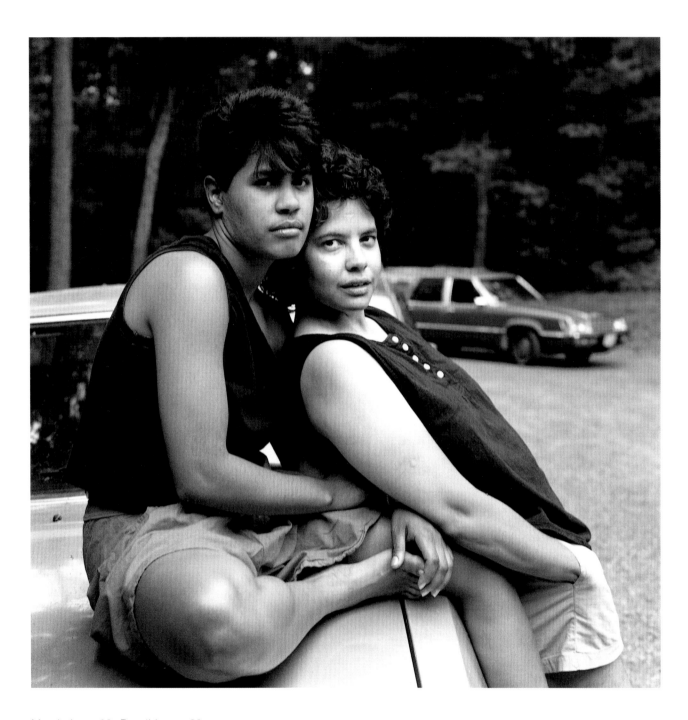

Marybel, age 26 Brunilda, age 32

marybel
brunilda

Marybel, age 35. There are eight of us altogether: five sisters and three brothers. Bruni is the oldest girl and I'm next to last. We grew up in Manhattan and we consider ourselves Puerto Rican. My mother taught us to be there for our sisters. The oldest sister defended the next and so on. Everyone was once a big sister. That made us tight.

As the oldest girl, Bruni was the brains of the family—quiet and shy, but in tune with everybody, taking control. I tagged along behind my sisters—the shadow. Bruni was a skinny, dorky kid with long braids. She'd show us all the new dance steps and she played the clarinet. She tried to go to the Academy of Music, but she didn't make it. She was devastated. She was my idol—always has been.

When I was in my mid-20s, Bruni asked me to go to Massachusetts with her. She knew I needed to get out of New York. I looked at the night sky here and literally fell in love. I quit my job and moved. At first, I was terrified. There were no lights and everyone looked the same. Eventually, my way of seeing changed. I finally became my own person.

In a large family, you tend to be stereotyped. Bruni is the big sister and that never changes. She'll always worry about me. She's easy to talk to and works as a traveling nurse. I'm the shy, hateful one who doesn't like anyone. But, I'm hardworking, easygoing, and straightforward when I need to be. I work with the elderly. At home, they call me Guti. Here, I am Marybel. Guti and Marybel are very different people.

My sisters are strong, incredible women. I have a part of each of them. You can talk to them about important things, stupid things, and female things. And yet, I feel really distanced from my sisters. They're all in Brooklyn and they're a lot closer to each other. I haven't been calling. I'm doing my own thing. I think my sisters are saddened by it. I know they would like me to be in New York. But I'll never go back. I have a partner and two children now. This is home.

Brunilda, age 41. There are different versions of the story, but when that picture was taken, Marybel was in New York and she was unhappy. She was a loner. The other girls were involved in their own things. As the big sister, I wanted to help. I was making a change, out of the city, out of my career as an electrician and into the health field. I had applied to college in Massachusetts, and I said, "Guti, let's go!" Strong-willed, adventurous, and seeking something better for herself, she said yes. We rented a house in the woods and lived together for the next five years.

As the oldest daughter, I was the second caregiver, after my mother. I've been parenting forever. There weren't any advantages to being older. I was put in a position where I felt responsible for the family. Both my parents worked, so after school, I had to start dinner, clean, fold the laundry, and keep everyone happy. It was a lot of work. Marybel was a baby. Her job was to be cute. I also got in trouble for everything that everyone else did because I was the oldest. On the other hand, we had a lot of fun, too . . . especially the girls. We'd dance, play all the sports. We were a pretty affectionate family, especially as kids. Now we're more distant.

I've always been the one to go, to experience different places. I'm a traveling nurse and when you move like that, it gets tougher to stay close. I feel like I'm part of the family, but not an integral part of it. The physical space makes the relationship much less than you want it to be. I try to call everybody and let them know that I'm available for them. I've even tried to get Marybel back to New York, but once she's planted somewhere, she stays. She claims she's happy, but I'm not convinced.

I think Marybel is a beautiful woman—all my sisters are. The bond between sisters doesn't get shattered no matter how many oceans you go through. As we get older, it gets harder to maintain the ties, but you still feel something very essential. Then you can talk sister to sister, woman to woman, friend to friend.

As the oldest girl, Bruni was the brains of the family— quiet and shy, but in tune with everybody, taking control.

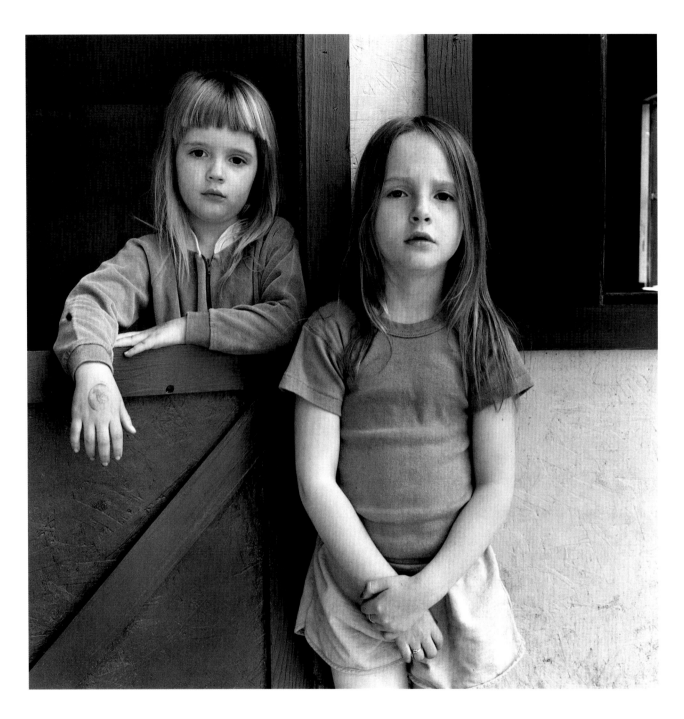

Nora, age 4 Lucy, age 7

nora
lucy

Nora, age 14. When I was small, I really worshipped Lucy. She's three years older, and I thought she knew everything. Together we'd play dolls, look for fairies, and collect shells in the summers on Cape Cod. Sometimes we'd fight because she preferred to play with her friends over me.

We stayed close until she was 11; then things changed. She was going to a different high school, and we had no friends or interests in common. I liked drawing, school, and going to the movies with my friends. She was into aikido, cello, and looking for colleges. Now, she's into her boyfriend. Because she was gone so much, we were never together just one on one. It makes a big difference. We didn't fight, but we weren't close. Now, we're getting close again, and I really enjoy spending time with her.

You can just feel Lucy's presence in the room. She's beautiful, confident, and powerful. She doesn't get along with everybody and probably wouldn't describe herself as popular, but she is. I'm generally more shy and quiet than Lucy. Sometimes it's easier to be with my friends because I don't have to compete with them. When Lucy is around, I can feel kind of boring. Lucy is the wilder one, the troublemaker—wanting her freedom and fighting with my parents. I fought with my parents, too, but not nearly as much. Although she's calmer these days, she still occasionally pushes the boundaries. Still, I love being with her.

When my parents got divorced, I was 9. We sort of came together as sisters, but we reacted differently. I thought my parents would get back together. Lucy knew they wouldn't. She was uncomfortable with my parents seeing other people. It was hard for her to talk about. I was sad, too, but I think I was more okay with my parents moving on.

Sometimes, we'll do things like go out to dinner, and I like it. I wish I saw her more often, because I think we'd be closer. I love Lucy very much and I'm glad she's my sister.

Lucy, age 17. Nora and I are almost polar opposites. These days our differences aren't really grounds for a fight. Most of the time, we get along really well. My sister is stunning, brilliant, artistic, and charismatic. Yet, she's the most shy person I know. If you're just meeting her, you'll have no idea what she's really like. I'm outgoing and loud compared to her. It's not that she doesn't have a lot to say; but I'm bolder, less modest—and I'm certainly not shy.

Nora is always at home, and I'm hardly ever home. I go to school far away. I shuttle back and forth between my parents' houses, and my boyfriend lives an hour away. I don't know why she's at home so much. It's not from a lack of friends. Maybe it's a lack of self-esteem.

Growing up, she always seemed much younger, even though we were close in age. I think she was always conscious of having to live up to some older sister. I had more knowledge, and I'd rub her face in it. She couldn't be right if she disagreed with me. Sometimes I told her things that weren't true just to frighten her. Once, I told her that her teddy bear had cancer. Conversely, I was the one who got in trouble when we fought because it was my job to "set the example." Nora was cute, believable, dramatic, and prone to burst into tears. And, of course, she'd say it was my fault.

My parents divorced when I was 13. It forged a major bond between us. Our parents had betrayed us in the greatest possible way, and we were both angry. We only had each other to depend on. I spent all my time with Nora and half my time with each parent. We've worried about each other, too. She was seriously ill and spent a long time in the hospital. And she's watched me struggle with drugs. Nora hated it. I'm sure she was trying to protect me, but she couldn't—nobody could.

Being an older sister, having a younger sister . . . I'm really grateful for it. I love Nora so much. We're more part of one another than anyone else in the world. She's my most permanent friend.

I think she was always conscious of having to live up to some older sister.

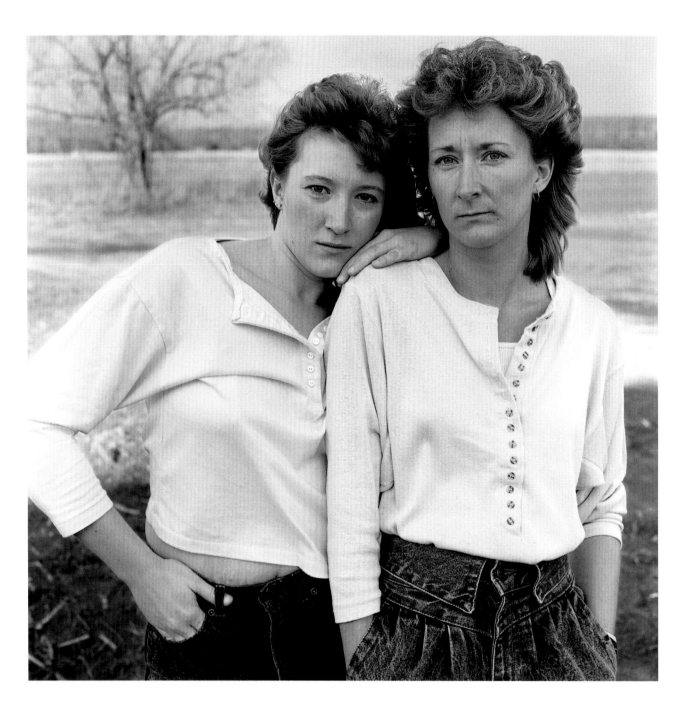

Carol, age 22 Sandra, age 32

sandra
carol

Sandra, age 45. My sister, Carol, and I are very different, from the way we look to the way we live our lives. We have very different ideas, and we know there are things we cannot discuss because they're just too delicate . . . too close. But we've chosen to put all of our issues aside and make every effort to stick together, to be there for one another in spite of all the craziness. It can be really challenging, but your sister is your sister. She's worth the effort.

Growing up with Carol was wonderful. I was almost 10 when she was born, and I remember how tiny she looked when my mom brought her home from the hospital. My God, she was a beautiful baby—round cheeks, long, blonde curls. Our mother worked nights as a short-order cook, and I was sort of the mom on duty when she left in the evening. I cooked dinner and took care of my sister. I loved getting her ready for bed in her zip-up pajamas. I would count to three and catch her as she jumped off the changing table. We lived in a really small cottage, and our bedroom was a long sun porch. My brother slept on one end, and I slept on the other. Carol's crib went right next to my bed. If she cried at night, I would prop up a bottle for her.

Because I was so much older, I was becoming intensely focused on my friends when she was 3, 4, and 5. She was left behind, and I think she started to feel like an only child. At night, when she couldn't fall asleep, she'd ask me to tell her stories about when she was little. I would tell her crazy stories, and we would laugh and laugh. Carol was a lot of fun and spoiled rotten. She was referred to as "the baby" until she was a teenager.

Recently, Carol mentioned the day she almost drowned. I was 15 and she was 5, and I had taken her to a friend's house. We lived on a river, and we spent a lot of time on its banks. That day, I was enjoying the attention of a boy, and Carol was bobbing around in a tube on the water. As I looked away from her, she slipped through the tube, sinking like a stone. I reacted immediately and pulled her from the water. She remembers looking up through the water, seeing the sunshine through the middle of the tube. At the time, it was nothing to me. I was just 15. Today, I realize how my life could have changed—how she could have drowned and I would have been responsible. The thought of it rocks me to the core.

When I got married, I was 20 and Carol was 10. She cried when she saw my wedding dress because it was my "you're going to lose me" dress. My son was born the year I turned 22, and I suffered severe postpartum depression. As much exposure as I had had to child rearing (I practically raised my sister), having my own baby was completely different. The hormone business really threw me. I was in therapy and on antidepressants for almost two years. Carol was in high school then, getting in and out of trouble, skipping school, and giving my mother a real run for her money. Carol was going through adolescence, I was going through postpartum depression, and my mother was going through menopause. We were three needy women who just couldn't be there for one another.

When Carol got to be 15 and 16, I was raising two children and she was dating. My father could not accept that his baby was growing up any more than he could accept it when I grew up. She was going out a lot and coming home late. When she left home at 18 and had a child of her own, my father was disappointed in her. At the time, he shunned her and poured his attention on my family and me. After being the cherished child all of her life, Carol was devastated. I basked in the attention I had missed when Carol was born, completely unaware of its impact on her. At some point, the tables turned, and she was once again in the limelight, leaving me and my family out in the cold. Being older, I could see what was happening. We talked about it, and we promised that we wouldn't be pitted against each other. I do my best to overlook the attention she gets, and she keeps it to herself. It's okay. We know we can do it.

We've chosen to put all of our issues aside and make every effort to stick together, to be there for one another in spite of all the craziness.

I don't agree with a lot of decisions my sister makes. She's very attractive and has an outgoing personality, and she likes being the center of attention. She's had a lot of relationships, and I've been married to the same man for twenty-five years. I've always tried to mother her, something she hates. But she's on her own nontraditional path. She won't let anyone control her. She's willful and always in charge. I often have to keep my thoughts to myself, brooding over issues until I get over them.

Carol recently got pregnant, and she wouldn't tell me because she didn't want to hear what I had to say about it. The distance kept us both safe. I wanted to share with her the baby's heartbeat, the ultrasound pictures, but I couldn't because of the "safety" distance we had created. The more I thought about it, the more I wrestled with it. How were we going to get past this chasm? Everyone in town knew it was a boy, but she wouldn't tell me . . . and I refused to ask. Our stubbornness was coming between us, and it was tearing me up inside. I finally decided it was up to me to swallow my pride, keep my opinions to myself, and confront her. When she was about seven months pregnant, I walked up to her at work and asked, "Hey, fat mama, how do you feel?" She turned to me and said, "I feel *fat!*" We hugged each other, and the chasm disappeared. The end. No discussion. We just let it go because we had to. There was a baby coming. I was delighted to be back in the loop. We spent the next two months shopping and planning together. I feel that the baby has renewed our commitment to each other as sisters.

Now that my children are adults and Carol's older children are teenagers, we share a lot of conversations about child rearing. She helps me remember what it was like to be 21 and willful, and I listen sympathetically to her teenagers' woes.

We are very aware of each other's emotional needs, and we act on it. I suddenly feel that Carol is "mothering" me as I approach menopause with all of its trials. And I like it. It's so important to me to keep our relationship going. She is my sister, and I love her. We both know there are things that agitate each of us about the other, but I want to look beyond those things. I won't let anything come between us, no matter what.

Carol, age 35. Sandy (Sam) was already 10 years old when I was born. She has always been like a second mom to me. She took over that sister/mom role right from the start. Our relationship changes like the seasons. It runs an unpredictable path between closeness and distance. When we're not on the outs—the outs being when her opinion clashes with my life decisions (which is a lot of the time)—we get along very well. There's a lot between us, but there are those things that we rarely bring up because they upset us both.

Growing up, Sam was a great "mom." She'd do things with me like take me for a ride, sing songs, tell horrible stories, and wake up with me in the middle of the night so I'd feel safe walking the ten feet to the bathroom. She took pictures: me cooking in the kitchen; me and T-Tam, the dog; me making Jell-O. I guess I was her photo study. These are the only pictures of me growing up.

When my sister was a teenager, I kind of lost her. She had her own friends. She was still motherly, but in a different way—more like, "You shouldn't do this, you should do that." I was going to get her opinion whether I wanted it or not!

When I was 10 and she was 20, she got married and moved. I was truly crushed. I felt like she was leaving me forever. Just before she moved I said, "I'm not going to be able to wake you up Christmas morning." When Sam started having children, I was very jealous of her. My father doted on her and the kids. I, the baby, felt left out.

I was pregnant with my first baby at 18. Sandy was there for the birth of my son. The minute I thought I was in labor, I called her. She dropped everything and was at my house within the hour. She stayed with me the whole time. I have pictures of her with the stopwatch. I know if I ever needed Sandy, I could count on her. But it would have to be a necessity.

Thinking back, I have begun to realize that we never complimented or encouraged each other directly. It's always been through a third party without the other knowing. Sandy was always quite capable of hurting my feelings and even better at making me feel great about myself. She's a very sensitive person, and I guess I've learned to keep my feelings to myself, good or bad. She felt I wasn't mature enough to have children. I didn't agree with that, so we didn't talk about it. Everything goes well as long as we avoid certain things.

We were able to be together on the kids, though. Sam really loves babies and children, and I learned a lot from watching her. If I was having trouble with something about the kids, I could call, and we'd hash it out. We'd come up with a plan to handle it. She's always been pretty good at problem solving . . . and creating problems, too. I'm not any better. Sometimes I wish I could be more like her, more capable, thoughtful, and organized. But she's got a million things going on at once, and I wouldn't want the stress.

Sandy is judgmental of me, which is why I don't confide in her about certain things. It's disappointing. I'm more apt to talk to my friends about real personal things. She likes structure and being in control of a situation, and I'm not that controllable. She likes to know exactly what's going on so she can deal with it and put it to rest.

I'm pretty good at getting out of the way when she's judging. It's self-preservation. I don't want to have a tiff with her. I'd rather not speak to her for a month or two

We hugged each other, and the chasm disappeared. The end. No discussion. We just let it go because we had to. There was a baby coming.

I won't let anything come between us, no matter what.

than to have an argument. I was recently pregnant with my youngest son, and I never told her. I didn't tell her because my son's father is 24 years old, the same age as her son, and I already guessed her reaction. I just didn't want to deal with it. She found out, of course, but we never discussed it. In fact, we didn't see each other for several months, and then she found an excuse to come and see me at work. There was no denying that I was pregnant at that point. She brought something for my daughter and said, "By the way, how are you feeling?" We went from there. I just wanted her to be happy for me and that's it. She had plenty of time to think it through and accept it. She came around when she was ready.

So, yeah, Sandy's judgmental, but she's very loving, too. She'll send me a beautiful Mother's Day card and make me cry. For Christmas one year, she found an infant photo of me and had it blown up and framed. Once, she sewed a stuffed rabbit just for me. She's not one for a lot of "I love you's," but she does and says things that are very meaningful. About ten years ago, she said to my mother, "She's taking care of that baby a lot better than I ever thought she would." I don't think she knows how much of a boost in my confidence that was. When Sandy recognizes me, it floors me. I really crave that from her.

I don't know how our relationship survived all the crap in our lives. I think it has to do with the girl/sister thing. There's a camaraderie . . . a determination. We've seen many things fall around us. In spite of our differences, we're going to make it work. We have a need to connect and be together. We'll find a way to get to the heart of the matter.

When Sandy recognizes me, it floors me. I really crave that from her.

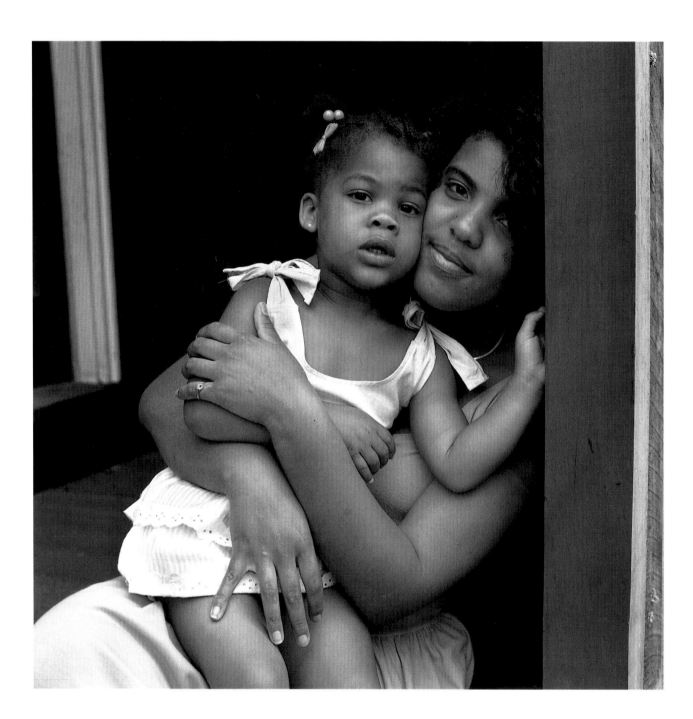

Imani, age 2 Maya, age 15

In her presence, I don't lie to myself about things.

I am recognized in a very deep way. **Sarah**

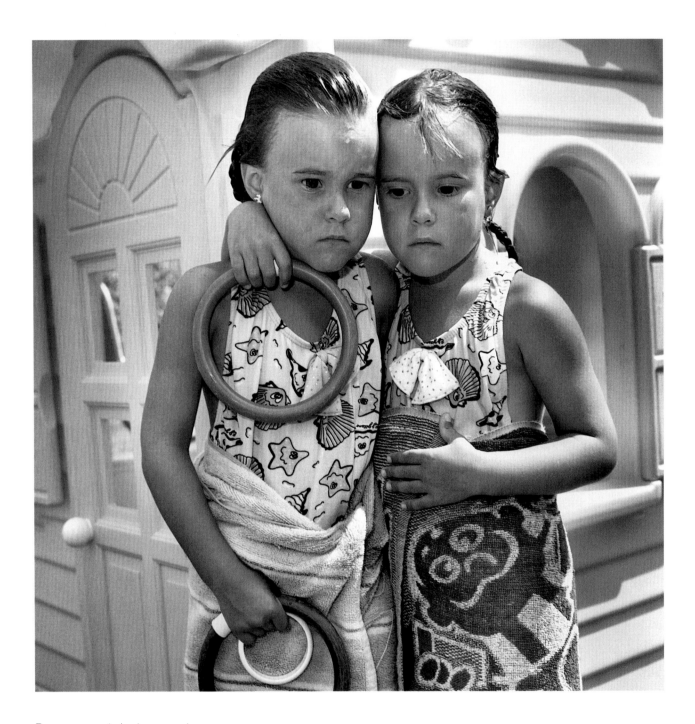

Roxanne, age 4 Larissa, age 4

roxanne larissa

Roxanne, age 15. Recently, everybody has been noticing that I have a mole on my right eyebrow. It helps people tell the difference between me and my sister, Larissa. When we were little, it was the freckles on our noses. Before, I always wanted people to know that we weren't the same person, but I don't care anymore.

A lot of people tell me that I'm more outgoing than Larissa. Larissa is not as shy as everyone thinks she is. People also say, "Roxanne is the sporty one, and Larissa is the dancer." It doesn't really bother me, but it's kind of weird that they label us like that. I see myself as really active, but my sister is also active in her own ways. We dress differently, but basically it's the same style. We don't dress in the same colors, though.

We shared a room up until seventh grade. Then my oldest brother went off to the army, and we got our own rooms. Mine is blue, and I have a lot of sun, moon, and star things, and my sister's is light yellow. She has a fish theme with lots of "citrus-y" colors. I love having my own room, but a lot of the time we sleep in the same room. We'll start a movie, or I'll get scared and end up in her room. It's really comfortable.

I tell Larissa more things than anyone. When we fight—usually about clothes or chores—it doesn't upset me too much, because she and I can always fix it. It's much scarier to fight with my friends. My sister doesn't have a choice. She's stuck with me.

I'm more willing to be similar to her, now. Everyone can basically tell the difference between us, but sometimes in pictures, even I have to look twice. More and more, we find ourselves saying the exact same thing, or I'll start to say something and she'll finish it. We spend most of our time together. She's my best friend.

Larissa, age 15. When we were growing up, we were dressed alike, but in different colors. Roxanne wore purple or blue, and I wore pink. It was really for other people. When we got to second grade, we didn't want to have the same clothes anymore. We didn't want to be treated as one person anymore. Sometimes people still call us "the twins." They don't say our names. You just want to be your own person.

My sister is known as the sporty one. I'm known as the dancer. I swim and play basketball and volleyball. But because people don't see me on the field, they assume I don't play. The labels limit us. Everyone says that I'm quieter than she is, but I don't agree. I think we're both outgoing. We both love having fun, going to the beach, and hanging out with our friends. When we're alone together, we have long talks—girl stuff. When we fight—usually over clothes—we yell, and I get so frustrated that I leave the room. She wants to talk about it. I don't. She usually wins. We end up talking about it.

I want to grow up and experience things on my own. I'm done being a kid. How would I handle drinking or boys? I don't know about Roxanne, but I want to get out of the town I've grown up in and go on to better things. I want to live at the beach and do art. I'm just getting started, but that's what I want to do—maybe graphic design or photography. We both want to go to college.

Once, when we were just babies, my uncle accidentally forgot Roxanne on the beach. When we got back to the cottage, my grandmother freaked. Roxanne was still on the beach, all wrapped up, sleeping. I've been around Roxanne for so long that I can't even imagine who I would be if she weren't there. She's my best friend. Even though we look the same to others, deep down, we know we're not.

Once, when we were just babies, my uncle accidentally forgot Roxanne on the beach.

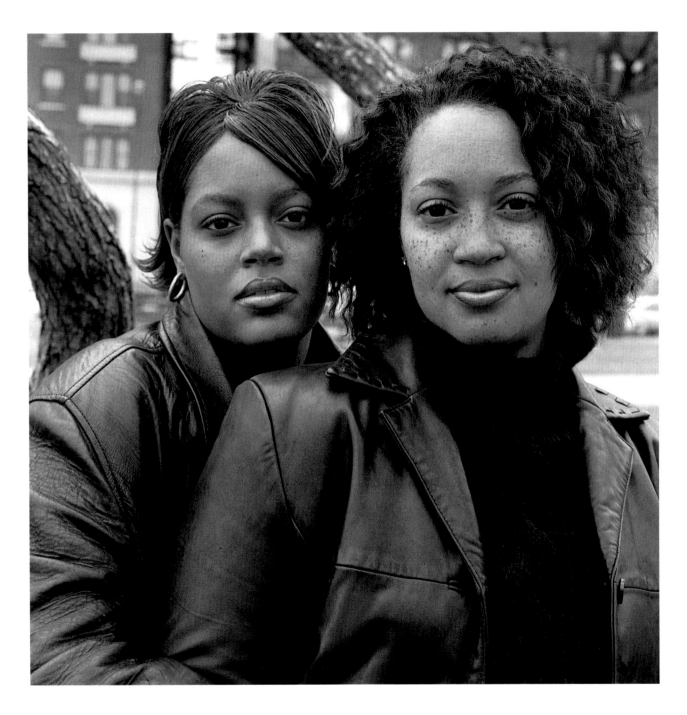

Brandy, age 23 Deona, age 33

brandy
deona

Deona, age 33. When my first daughter was born, my sister Brandy drove all night from Florida to see her. With my second, I was already eight centimeters when I got to the hospital—too late for an epidural. I was thinking, "I can't possibly do this," and Brandy was by my side telling me I could. And she was with me again for my third. How she manages to get from the south suburbs to downtown Chicago in twenty minutes, I have no idea, but she's always there. That's what characterizes our relationship.

Brandy, my brother, and I share the same mother and father. Together with step- and half-siblings, we are seven. Being ten years apart, Brandy and I were never playmates. I was the big sister. As the oldest girl, I had more responsibility for Brandy—for babysitting, feeding, changing diapers, or tying her shoes. It suited with my personality. But soon, I was away, first at college and then at graduate school.

My husband, Steve, helped bring Brandy and me together as peers. In talking to him, she began to see me as more than just the older sister. And I started to see her as an adult. I became interested in her high school experiences and her plans for the future. She now owns and operates two day-care centers and has three children.

Children put our relationship on a more even playing field. She became a wife and mom much younger than I did and our kids are only a year or two apart. We've both been utterly perplexed by our 2-year-olds. I may have more work experiences to share, but Brandy is very wise when it comes to kids.

More laid back than I, Brandy keeps me "real" and grounded. I wonder how to juggle everything—marriage, kids, work. I need the books. I need the support groups. Brandy just does it . . . with incredible energy. I'm sure it's stressful for her at times, but she makes it seem pretty smooth. Something in her approach to life lets me know that everything is going to be okay.

Brandy is my best friend. I call her to vent, to seek opinions and advice about things that range from kids to husbands to fathers to brothers. She gives me perspective because she understands intuitively where I'm coming from. She's my voice of reason and wisdom. She's always been there. She'll always be there.

Brandy, age 25. By Deona being so much older, we didn't have that much of a relationship as kids. I was coming into my adolescence when she went to college and at the time, we didn't get along. She wanted me to be more like her. She was uppity and prissy. She wanted me to curl my hair and wear certain clothes, and I wanted to dress like a boy.

Senior year of high school, I wanted to go to college. Deona would tell me one thing, and it would take three more people to tell me the same thing before I realized that I should have just listened to her first. She got me into a good college and that's when we started to bond. I grew to value her opinion so much that if I made a move—school, classes, life, anything, I'd go to her first. As she helped me to become more responsible, it became a value of mine too.

Deona had just gotten married and was about to have a baby. I was wondering how she was going to deal with it, because she wasn't really a baby person. But right after college, I started having kids as well. Our kids are all a year or two apart and they became a big tie for Deona and me. It's something we've both been through. We talk every day. She has accomplished more than I have but the age difference doesn't matter anymore.

Our communication is the most important thing. I can tell her anything and she won't judge me. There's a real feeling of acceptance. As a woman, she is kind, loving, responsible, and determined. She gave me motivation and let me know which way to go. She encourages me. She pushes me to finish. She gave me the foundation.

Children put our relationship on a more even playing field.

Something in her approach to life lets me know that everything is going to be okay.

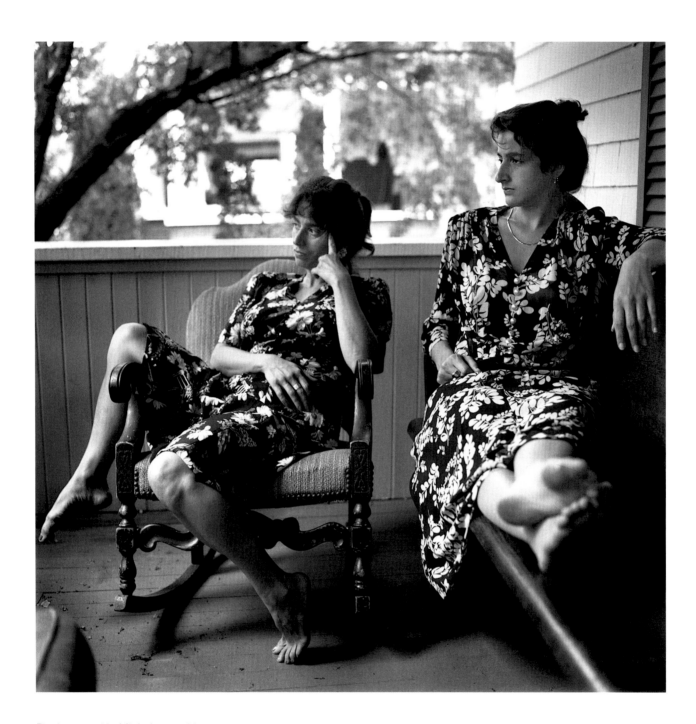

Denise, age 40 Michele, age 24

denise
michele

Denise, age 50. Michele and I are the bookends, almost a generation apart—sixteen years, two brothers, and two sisters between us. As the oldest and the youngest, we bear witness to the story of our family, our parents, our siblings, our place from very different vantage-points. We each acknowledge that our place in the birth order is significant and intense. Yet, we feel that between us is the whole record. Living in the same house barely three years, we were not children together. Still, we are the only two who have made the same community and neighborhood our home.

To me, this picture signifies the grief period after my father's death. It was a really intense period for us that we could only appreciate afterwards. We were all in an altered state of consciousness. It doesn't feel like my other sisters are missing. Michele and I shared some experiences that the rest of my sisters and brothers didn't. We spent more time with my dad than the rest of my family because we lived in the same community. Michele and I were there alone in the hospital together, witnessing my father's rapid decline, well before the rest of my family arrived.

The weekend before, we had had a Memorial Day picnic, and I remember my dad playing Wiffle ball with my sons. When my dad was a child, he had had rheumatic fever, and consequently, there was a problem with a heart valve that only really started to affect him when he was older. He was very active and felt it was affecting his ability to play tennis. His doctor suggested that he could have the valve replaced, like getting the valves in your car replaced or something. It was elective surgery. He didn't have any heart disease at all, and . . . he wasn't debilitated in any way. What, he wanted to improve his tennis game? But he decided to do it, and the Tuesday after Memorial Day, he went in for the surgery. A week later, he was dead.

He had one system, one organ failure after another. They couldn't figure out what was going on. Michele and I were both there when the surgeon came out, blood on his hands, and said, "I have to go in and do another surgery." They did a second open-heart surgery to remove a huge blood clot that had collected. At that point, there was so much damage done that he couldn't recover. It was in those first three days, before the rest of the family arrived, that Michele and I witnessed so much together.

Family drama was layered on top of this. My father and mother had moved out to Arizona when Michele was in high school in an attempt to save their marriage. They struggled for a while. They divorced. Then they decided to work it out. They came back East, but here to Springfield, Massachusetts, where I live, and remarried. Shortly afterwards, my mom became a fundamentalist Christian. My dad didn't want to follow her into that life. It became a big schism in our family because of the six siblings: five of us are very progressive, and one of us is fundamentalist Christian.

My parents were pursuing another divorce. They had been separated for two years, and my dad had really started to pick up his life. He had been really crushed by my mom leaving Springfield and lived alone for a while. I got really close to my dad during that time. Then he began to see someone else. He wanted to finalize the divorce. My dad's second divorce from my mom was to become final on the day he died—today, June 6, the day I am telling this story, the anniversary of his death. My father left me as executor of his will, and all of the papers say he was divorced. My mom wanted to overturn that he was divorced, not for financial reasons, but because she felt that God had taken him before the divorce was final. It was very stressful and painful for all of us. It was my mom, his fiancée, and all of us siblings around my dad on his deathbed.

We feel his death was an incredible mismanagement. We were savvy to medical information and hospitals. I had practiced lay midwifery. One of my sisters was an R.N. and had worked in operating rooms. My

We feel that between us is the whole record.

other sister worked for the American Heart Association. The doctors probably didn't have the answers, and we kept asking questions. They avoided us. They'd go out the back door rather than deal with us.

In our attempts to gain control over the experience of my father's death, we, as sisters, got into this incredibly manic state of wanting to understand. We demanded his records within twenty-four hours of his death. The night after my father died, we recorded a several-hour conversation about all the events of the past six or seven days, as we recalled them. Then, in the months after, we sisters became completely obsessed and did tons of medical research. It was just the females of our family. I have a picture in my mind of Michele and me spending hours in the library together. We all had different pieces. My sister in Philadelphia was exploring the American Heart Association. My sister Terry, the nurse, was doing research in her own local medical library. We were comparing records and finding omissions. We kept asking questions. All this analysis—really to no avail. I think we wanted to hold somebody accountable. We consulted with a couple of law firms. They didn't take the case because they felt it would be too difficult to win or settle.

How mixed up our feelings of loss, grief, and sorrow were with our own powerlessness and our bearing witness to his mismanaged care, the suffering, this needless downward spiral to his death. We were so unprepared for how it would affect us. We were all so raw. The death of a parent is really difficult. Michele was fairly young—in her early 20s. I was not yet 40. That was always one of the things . . . my father wasn't there for Michele's wedding. And yet, it was also this incredible bonding experience for Michele and me. It was the most significant experience in our lives other than the births of our own children.

What I see in Michele is a person who would be my friend even if she weren't my sister.

What was true about us at the time of this photograph and is still true is that Michele and I really support each other. We've gone through some hard times together as sisters. We've struggled in terms of boundaries professionally. We're both mediators. We don't travel in the same social circles, but we know a lot of people together. We both live in the same neighborhood (Michele married a man with roots here), and we share an interest in restorative justice. After my father died, I did mediation and violence prevention work in schools. Before that, I was a midwife, working with pregnant teens. Now, four children later, I'm finishing up my Ed.D. Michele's background was in corrections. We've talked a lot about her professional direction and the compatibility with motherhood. She's now in graduate school for school psychology. We've shared some training contracts together and it's worked out fine. We are so process oriented that if something comes up, we make sure that we deal with it. Our support and commitment to working

What was true about us at the time of this photograph and is still true is that Michele and I really support each other.

issues through is what really characterizes our relationship now.

As the oldest, I had a lot of responsibility for my siblings, because there was a lot of dysfunction in my family when I was an adolescent. I was "parentified." I think my siblings see me as the older sister even though I stopped thinking of myself that way. I recognize that it plays into our relationships. Certainly, we go to each other for advice. But I think they perceive me as being incredibly strong. It's probably hard for them to see me as vulnerable or weak. It's never occurred to them that I could feel insecure. Michele has a more realistic view of me. She's witnessed so much of my life. In the last year, I had surgery for endometrial cancer. Since I've been separated for over five years, she and my other sisters and my mother were my main support.

So much has happened for Michele in these past ten years. She's gotten married, had two children, and developed a professional life. I've seen her seeking, changing, and growing. I've seen her trying to integrate a professional life into her life with children. She asks me a lot of questions about child rearing. I can't come to her in quite the same way, but I have certainly shared my own struggles around parenting. I've shared a lot of my own difficulties, disappointments, and sorrows. She comes to me with things about which she already knows my response. She's looking to feel validated. We talk and listen to each other a lot.

What I see in Michele is a person who would be my friend even if she weren't my sister. I really like and respect her. My family is enmeshed in my life. If any one of my siblings didn't continue to exist, there would be a huge gap. But, of all of them, Michele is the most familiar, the most known to me. She is the one I will seek out most often to speak to or for support. We've witnessed way more in each other's life than anybody else in our family. Next to my own children and husband, she knows more about me than anyone else . . . me, my life, my marriage, my work, how I think. I'm more intimate with her than with anybody else. That's not because she's so much better than my other siblings. It's more a familiarity, a continuity. It's circumstance, proximity, time spent. We're close enough to have a history present to us.

I have four kids—three sons and one daughter—and I feel sad that my daughter doesn't have the experience of having a sister, although our relationship is really close. It's something I wish I could have given her as a gift. Sisters' journeys can be closer together than a mother's and a daughter's. You inhabit the same generation and the same family history. My daughter's experience of what a family is is completely different than what mine is and was. I imagine that she'll try to seek out in friendships, and with her female cousins, what I have with my sisters. I love the fact that I have three sisters

and not just one. I love the constancy of knowing that my sisters will always be there through my life.

Michele and I have grown and matured in each other's company. For the past sixteen years, almost a generation between us, our daily familiarity has allowed us to share concerns, triumphs, struggles, celebrations, and births and deaths in the intimate sisterly ways that are only natural and possible in such circumstances.

Michele, age 34. This is the ten-year anniversary of my dad's death. I was 24 and Denise was almost 40. This photograph feels to me like an intense moment of grief frozen in time. When my father went into the hospital for heart surgery, Denise and I were there, too, together. Within the first twenty-four hours after the surgery, my father began to have problems. Things got real serious, real quick, and we knew he was in trouble. I have these flashing images of the two of us in the waiting room, talking to the doctor, and then making phone calls to the rest of the family. Denise and I were the only two who lived in the same city—and state, for that matter—as my father. When his situation worsened, the rest of the family, my other siblings and my mother, came from other states to the hospital.

I think there was some level of denial around the reality of my father's situation. But Denise and I were emotionally in the same place at the same time. When it came time to make a decision about whether to continue life support, there were some in the family who were unsure about what to do. I think there was a moment early on, before anyone else was there, when things had gone bad with my father, that Denise and I had begun to let go. Even though no one had said that my dad was dying, we kind of knew. There was this incredible sense of mutual support and understanding between us.

There is a sixteen-year difference between Denise and me—with four others in between—so we didn't grow up together. She was actually out of the house and off to college the year after I was born. There are also eight years between me and the next-youngest sibling. There were times growing up that I felt a loss—left out because the five of them all had this life together that I was not a part of. I don't experience it that way at all now.

When I turned 18 and had graduated from high school, my mom and dad moved near Denise. I moved to the area also and lived with Denise and her family for a period of time. Our relationship changed throughout the years, and Denise and I became friends. When Dad died, I realized that we had become peers. I grew a lot as a result of Dad's death. I can remember assuming responsibility

for things that I wouldn't have in the past . . . like notifying the extended family of his death and participating in the funeral arrangements. Denise and I spent a lot of time together in the weeks that followed Dad's death. There was this feeling of wanting to be with someone you knew was experiencing the same thing. It was an incredible bonding experience.

Because Denise is so much older than I am, ours has been a unique sisterhood. Although we grew to be peers, it was not always that way. When I was a child, I used to visit her in the summer when she was in college and newly married. She has been more than a sister—she has been a role model to me. All of my sisters have been. I think that a lot of who I am, particularly as a parent, has been shaped by my sisters. I saw them raise their children, and I have integrated different pieces of their parenting styles into my own life. Denise chose (as I also did) to put her career on hold when her children were young. Now that her kids have gotten older, she has had the opportunity to put more energy back into to her career, and she's done very well.

I have also been influenced by all my sisters in how I view myself as a woman in the world. We're all very strong, independent women—certainly not afraid to voice our opinions. I must give credit to my strong and very independent mother, who, while she grew up in a different generation, certainly passed on these traits to her daughters.

Overall, we're a pretty close family. For the past several years, we have gotten together during the summers as siblings and with our own families to spend time together, usually in Virginia Beach. Denise started this tradition. She actually footed the bill the first year for the whole clan. She said it was a gift to us and to herself. I think that it was also symbolic of the value that my father placed on the family. I know that my mother also takes tremendous pride in the fact that she raised six children who are close enough and enjoy each other's company enough that we choose to vacation together every year.

I am bonded with all my sisters, each in different ways. Denise and I share a special connection. We have lived in the same community, within fifteen minutes of each other, for seventeen years. The rest of our siblings live in different states. It is so strange where our paths have led us—that she, the oldest, and I, the youngest, should find ourselves so closely entwined. We have shared a lot; we have similar values and interests. We not only share family; we have also shared professional and community interests. I know that I have been very fortunate to have such a relationship, and I am grateful for that. She has been my sister, my mentor . . . my friend.

I think that a lot of who I am, particularly as a parent, has been shaped by my sisters.

There were times growing up that I felt a loss—left out because the five of them all had this life together that I was not a part of.

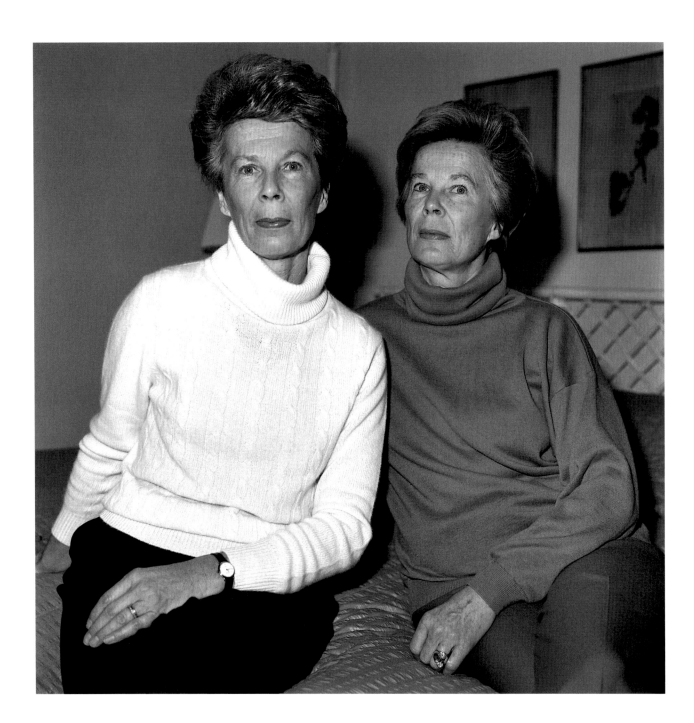

Carol, age 55 Cynthia, age 55

cynthia
carol

Cynthia, age 65. Mother and Daddy had been told that they would never have children. Having been married about eight years, they suddenly discovered they were having a child. For some reason, my father was convinced they were having twins. He took out an insurance policy against twins with Lloyd's of London. We were born, four pounds each, and Father collected $1,000 on the premium. They spent it all on hospital bills. But it made the *New Yorker* magazine. He was the first person ever to collect on such a policy.

We were terribly naughty when we were young. My poor mother! Once, we traipsed off in our snowsuits down to our neighbors' and experimented with stepping on the ice on top of their swimming pool. We fell right to the bottom of the pool. Fortunately, we got ourselves out, but we were "incarcerated" for the next ten days. In high school, we'd use our being twins to make trouble. Carol was quite cross with me once, and when my date arrived, she ran out, got in the car and pretended to be me. She had wanted to go out with him herself. We switched dates several times and they never knew the difference. Carol still gets a kick out of the fact that we look alike and suggests that we dress alike every once in a while. Eventually, we married roommates from Yale and lived in a Chicago suburb for many years. We got together a fair amount when the children were young to play tennis and bridge. We both liked to fish.

When we were in our late 20s, our parents died, and the trauma drew us together. My mother had such a slow death. She wasn't in pain or anything, but we both wanted to just put the pillow over her face and to be done with it. Father wasn't accepting her impending death at all. He was denying the fact that she would never come out of the hospital. After she died, he wouldn't go back into the house again. Carol and I had to go over there and see to everything. We were suddenly put in charge of Daddy, and it was terribly painful. He was so grief-stricken and lonely. We had to take care of him and our children and our marriages all at the same time. He died just four years after my mother.

At the time of the photograph, we were both living in Chicago, and it was nice for the both of us. We'd meet halfway between our apartments and then walk someplace for lunch. We saw more of one another then than we do now. We just seemed to be more accessible to one another. We winter in different places, and I'm not really a phone person. When we're both around, we'll see each other at the hairdresser's or when we go on fishing excursions together.

There have been some disappointments with my sister . . . not that I'm perfect. Sometimes she'll say things to me that she would never say to anyone else. And she hasn't always been as sensitive to my situation as I have been to hers. On the other hand, we've had some great fun. Once we left our husbands and small children behind and cruised through the Panama Canal and up to New York. It was the first time the two of us had been alone in a zillion years and we had a ball. We danced and kept everybody up very late every night.

Our life is one of total competition, with all the ups and downs that go along with that. We've both worked hard to mitigate some of the negatives. While we have some mutual friends, we've always tried to move in somewhat separate social circles. In an effort to develop our own identities, we've tried to do different things. And yet, we're all we have—one another—so I also feel a sense of loyalty . . . forever. If she needs me, then I will try to help her. We were the only two in that generation. Mother was an only child and Father had one niece whom we never really knew. And so, while we're very different, I think we're probably very close. I feel loyalty because she's my sister . . . because she's blood.

We'd meet halfway between our apartments and then walk someplace for lunch.

And yet, we're all we have—one another—so I also feel a sense of loyalty . . . forever.

33

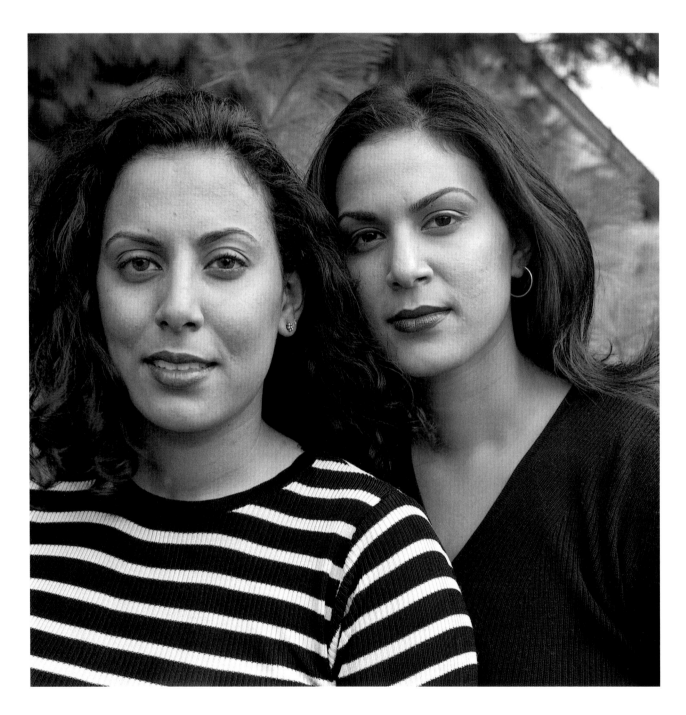

Serena, age 28 Neeta, age 26

serena
neeta

Serena, age 28. Until my marriage, I considered myself very Indian. I immersed myself in Indian people and culture. Conversely, Neeta was fully Americanized. Much fairer than I, she was happy when the kids at school mistook her for Italian or Greek. I couldn't understand that at all. Oddly enough, it was me who ended up marrying a white Protestant guy. And my sister, the girl who grew up so Westernized, is marrying an Indian guy.

We've reversed roles before. As a child, I was the troublemaker, whereas shy Neeta clung to Mom's leg. Sharing a room, often sleeping in the same bed, we were soulmates. Things changed in high school. I wanted to talk with someone who understood the intricacies of my teenage world, and that wasn't Neeta. Also, Neeta grew taller than me, and suddenly she got the new clothes. I abided by our parents' rules, where Neeta pushed the limits. I was an assiduous bookworm, and she showed up in high school pretty, trendy, and popular.

My mother always said that if she wasn't around, I was to take care of Neeta and my brother and they were to respect me as the eldest. I took that role to the extreme. It irritated me when Neeta didn't achieve like I did, and I'd say so. Obviously, we fought. Our only reprieves from conflict were the Indian parties we attended as a family nearly every weekend. Often not knowing anyone, we'd hang out with each other—*almost* like friends. Then I moved away to college. Homesick, I'd call and we'd talk forever, so things were great.

I still mother her. I want her to be more like me—serious and focused. She's wild and crazy and I'm such a planner that I know what month I'm going to have children. I say, "You're not saving. You're renting." Of course, she'll hang up, and poor Mom will be left to mediate between us.

But I also learn from our differences. Watching her, I've improved my social skills. She tries to improve my wardrobe. I admire her persistence and attractive air of confidence. I trust her implicitly as a friend and confidante. She is absolutely essential to me.

I remember a moment when Neeta was a kid. She's outside on the temple playground in her Indian clothes, doing cartwheels. She doesn't care that her shirt is falling and her underwear is showing. Just cartwheels . . . and cartwheels. She's a really free spirit.

Neeta, age 26. It's hard to say how Serena and I are similar. Growing up, she would play house and read her books, and I would be playing football or GI Joe with my brother. She was the responsible one following the rules, and I was trying to be outrageous. Even as adults, we're really different. She's a control freak, and I'm laid back. She's a saver. I'm a spender. I wear scrubs to work every day, while she wears heels. And yet, when it really comes down to it, I want to be just like her. Her life is right where she wants it to be.

Like a mother, Serena would make sure my brother and I weren't being too crazy. Sometimes, she'd tattle, and it wouldn't go over well. We fought a lot. She often disapproved (and still does) of my wilder ways. But we probably differed the most profoundly on the issue of our Indian culture.

Growing up, I wanted to be Americanized. My family would all sit down to an Indian dinner, and I'd be eating a peanut butter and jelly sandwich because I was "American." I shied away from everything Indian. Serena was the opposite. She was and is so proud of her Indian heritage. I thought she was a dork with her posters of Indian actors. At the end of high school I began to change my views about being Indian, and I saw Serena differently. It's ironic that she's the one who ended up marrying an American and I'm the one marrying an Indian.

Serena managed to pull off the perfect traditional Indian wedding, so I made her the matron of honor for mine. I chose her because I'm closer to her than any of our other friends. We never run out of things to talk about, and we really enjoy each other's company. She really is my matron of honor.

Sharing a room, often sleeping in the same bed, we were soulmates.

She's a saver. I'm a spender. I wear scrubs to work every day, while she wears heels.

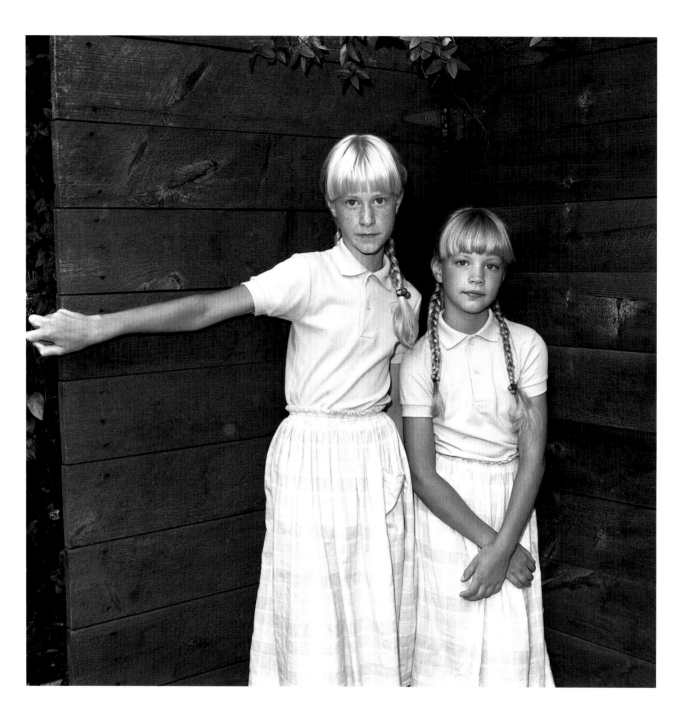

Katrine, age 11 Astrid, age 8

katrine astrid

Katrine, age 21. My mother always told Astrid and me when we were growing up that we had to be kind to each other. She used to tell us that if family members could not love each other and get along, then it was no wonder that world wars broke out! We spent most of our time together as children because my parents educated us at home. We learned everything together and enjoyed many of the same things—paper dolls, books, drawing, cross-country skiing, Frisbee, gardening. . . .

When we were younger and smaller, people used to think that we were twins. This was not surprising since we both had blond hair and most often dressed alike in dresses my mother sewed for us. Sometimes I thought it was funny that people asked if we were twins, and other times I wished that they would look closely enough to see that we were different. Now Astrid is often mistaken for being older when we are together because she is taller than me. I do not mind. I like being associated with her and being known as Astrid's sister.

For a while, I did not like being the older sister. I thought it would be nice to have someone looking out for me. But it was good for me to learn to set an example for my younger sister. Astrid and I are alike in many ways, but we are also very different. I prefer being close to home and my parents, though I have spent much time away from home. Astrid is brave and has traveled to many parts of the U.S., taking various art classes. She is more outgoing in meeting new people than I am.

Astrid has always been my best friend. She understands me and is always willing to listen to me talk about my studies or work or friends. And I enjoy sharing in her joys and sorrows as well. We simply love each other.

Astrid, age 18. Being a sister has been a source of great comfort for me. My sister, Katrine, is older by three years. We have always been best friends. I think being home-schooled strengthened our relationship as sisters. We were classmates and peers.

Katrine read the *Little House on the Prairie* books to me when we were quite young, and they inspired playing a game we called "olden days." We grew up without a television, so we played many imaginary and make-believe things. "Wedding" was a great favorite. Katrine was always the bride and I played the groom, which was fine with me. Playing "hospital" or "clinic" was another hit. Katrine is now in nursing school, so all those years of being poked with a mechanical pencil "syringe" are paying off.

Years have now gone by, and we are no longer the little girls we once were, but Katrine is still my best friend. We still love being together—going for walks, shopping, playing violin and piano duets, and late-night talks.

Katrine has been an example for me my entire life. Because she was older than me, she got to try many things before I did, such as learning to ride a bicycle, cooking, and multiplication. Her response to these different challenges affected how I, the little sister, viewed them. From her own experience, she would patiently explain to me that driving a car was not hard as long as you kept your eyes on the road and pushed the clutch down all the way before changing gears, and that the strictest college professors are sometimes the ones you learn the most from.

I am glad to be a younger sister since I have such a loving friend as my older sister.

Sometimes I thought it was funny that people asked if we were twins, and other times I wished that they would look closely enough to see that we were different.

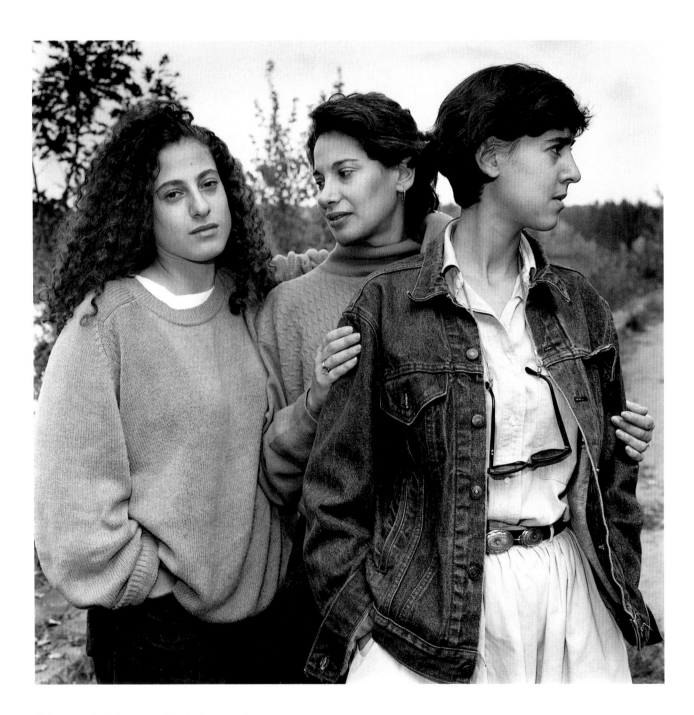

Debra, age 23 Judy, age 35 Audrey, age 31

debra audrey judy

Debra, age 34. Something terrible happened. When I was 8, my younger brother went missing. He was 5. My sister Judy was 20, and Audrey was 17. Something very bad happened to David. His remains were found six years later locked in a trunk in the basement of an abandoned house. It was life-changingly horrible, both at the time he disappeared and at the time he was found. Audrey and Judy were grown-ups, as far as I was concerned. Understand, I was a little girl. He was my companion.

Because of the difference in our ages, my sisters seemed a little remote, especially when I was young. Audrey and Judy have clashed with each other since they were very, very young. I mean, they haven't ever gotten along, and yet they remain close. When David disappeared, no one in my family was close to anyone else. Having come to the party a little late, I can only speculate that my parents brought Judy up differently than Audrey, differently than me. Judy was, and is, someone who always does the right thing. She was disciplined. Her room was neat. She did her homework. She was the good child. Audrey was the antithesis of all that. Audrey was, and is, emotional, and she rejects things. She had a knee-jerk rebellion style.

I'm not sure what happened to me in the aftermath of David. It was very shocking and horrible for a long time. I became scared of the dark in a creepy way that I didn't get over until college. Everyone was freaked out and doing this group crisis thing and I was the little kid, so I was partially excluded. But everybody felt sorry for me. I learned a lot, in that time, about the difference between true emotion and emotions people think they should have. It's not so much insincere as rote. I remember thinking that people's expressions of sympathy were just half a beat off true. That might have been the most striking and confusing element for me.

I had a very difficult adolescence. I was 14 when my brother's remains were found. I got sent to a boarding school, where I mostly did poorly and got into trouble. I was expelled from my first one. I did all the bad, rebellious, adolescent stuff like smoke pot and drink. I was trying to be just like my bad sister, Audrey. It was difficult for everyone. My mom was suffering from depression.

My parents both came from the generation of American Jews who were saddled with so much guilt and angst. I don't think they ever had a happy day in their lives. My mother's parents came from Poland and my father's parents were either born here or came here when they were very young. My mother's mother was an overbearing witch. Neither of my father's parents was warm or loving or accepting. Both of my parents were primed for depression. They had actually split up before my brother was gone. They had separated and then tried to get back together a little bit, but it didn't work out after David went missing. They were sort of like Audrey and Judy. They didn't really like each other, but they relied on each other. There was no resolution with respect to what happened to my brother. My dad died a month before my graduation from high school and my mom died when I was 25. They both died of broken hearts. It was very clear. So, early on, we were alone as sisters.

If I were to try to do an exposé of my relationship with my sisters, I would show you Judy's wedding album and then I would show you mine. Hers was a central casting wedding . . . Well, mine was, too. I had the fancy white dress and my husband was dashing in his tuxedo. But my mother is in Judy's wedding—my father refused to go. And there are lots of bridesmaids with those silly bridesmaid's dresses. At my wedding, the party was small, and my two sisters walked me down the aisle. The dynamics between my older sisters were there, of course, but I found it amusing. Judy made a speech and it was hilarious. I swear to God, I never knew my sister had a sense of humor. It completely surprised me. I know she spent hours on it. Audrey spoke extemporaneously, of course. She revealed to all my friends and colleagues that I wore black and did drugs in high school.

Hers was a central casting wedding . . . Well, mine was, too.

Both of my sisters are very accomplished. But they haven't changed a lot over the years. Judy is still a very toe-the-line, straight, mainstream conservative. She thinks Thai food is exotic. She's religious. She keeps a kosher home. She's clearly the matriarch of what remains of our little family. It's a role that comes to her naturally. She's the most stable . . . same house, same guy, same career. She has a daughter and a stepdaughter. She's the executor of both my parents' estates. Audrey and I moved away as soon as we could. So we were always returning to where she was, especially when my mom died and her house wasn't there anymore. Judy sort of became home.

Audrey is a magnificent person and I would do anything for her. She's both incredibly difficult and incredibly alluring. She has very set ideas of right and wrong, of the way things should go, and yet they never go that way, and she's offended by that. On the other hand, she's unbelievably creative, smart, insightful, and good-hearted. I know she'd do anything for me. She's always seen her role as my big sister/protector.

Because of the distance in years, I think I have a much more objective view of Audrey and Judy than they could possibly have of each other. They hate each other, love each other, need each other, depend on each other. It doesn't change—ever. It's entirely between them. As they get older, they seem to have a deeper need for one another, and so things slowly evolve. I love and need them desperately, too. I'd be completely lost, untethered, gone, without my sisters, especially before I was married and had a baby. When things aren't well with me, I retreat into myself. I don't share when I'm unhappy. David's disappearance and my parents' deaths are all profoundly isolating experiences for me. Not very many people understand what that all means, but my sisters do. We were the only ones who were there. My husband wasn't there. My friends weren't there. We were there. My sisters are the witnesses to my history. If it weren't for my sisters, I'm not sure I would have made it through my 20s. They were there when I was an orphan. We have a shared meaning that is essential and exclusive to us. After my parents died, my sisters defined my home base. They define the core of where I am and who I am. They have my history. They have my everything.

Audrey, age 42. My sister Judy is four years older than I am. Deb is eight years younger, and David was eleven years younger. Judy was born to be a grown-up, and now that she is, she's perfect. When she was young, she didn't take many risks. I'm sure she enjoyed herself, but to me it looked as if she didn't; she was too concerned that everything stay in the lines.

I tried to be trouble. I took any position opposite to that of my parents and older sister. My parents never

seemed particularly fun or imaginative or creative. In retrospect, I think they tried, but at the time, it wasn't enough for me, and I made that clear. I wanted to explore beyond the family boundaries.

Deb was so much younger. Judy was almost 12 and I was almost 8 when she came along. Our dynamic was set, and Deb seemed like a whole different thing. We treated her more like the baby than like a sister.

When Judy and I were younger, sharing a room was fun. We'd stay up late and fool around in the bedroom—putting on little skits. But then, that four-year difference really started to kick in. In junior high, she'd come home and do her homework, getting it all tidy and in the margins. I never did any of that, but I usually did at least as well in school, and that had to irritate her.

When we got into adolescence, our differences became acute. We got much more confrontational. She disapproved of me, and I thought she was annoying. I was extroverted and had a big clique of friends. Judy and I didn't try to understand one another, and we weren't close at all. Then she went off to college, and we saw each other less.

On the other hand, I appreciated that Judy kind of dealt with the parents—with my mother, anyway. Judy and my father had a harder time with each other. My father didn't deal with either one of us very well. He seemed to find Judy's righteousness stifling, and yet he couldn't really back me up because I was not behaving.

And then, the summer between my junior and senior year of high school, our brother, David, who was 5 at the time, disappeared. He had been playing down the street. It took me a really long time to wake up and have any consciousness of what had happened. I just didn't deal with it. Yet there were changes after that.

The following summer, when I was going to college, my parents had the three of us drive there together. It was the first time that the three of us had done anything like that, a sisters' road trip. I never knew whether my parents' aim was to foster that or whether it was because they didn't want to go. Either way, it's a great memory. We loaded up my father's car with my stuff, and the three of us went.

David's disappearance changed everything for us as sisters. From then on, we acted much more like sisters and took a much more active role in each other's lives. We stayed more in touch. The changes didn't crystallize overnight, but certainly that can be viewed as the catalytic moment when our relationship as sisters changed irrevocably. I became more protective of Deb. Judy and I went on complete stand-down. Well, I won't say that. There were still moments when Judy and I would circle around each other.

I give Deb a lot of credit for dealing with all of the issues around David's disappearance. She was very young and

Judy was born to be a grown-up, and now that she is, she's perfect.

they were only three years apart. I don't remember how she handled it at first, as I was off in my own trauma zone. We all were. We weren't a particularly close family, so when that happened, we all just retreated to our corners. We didn't talk about it. It's extraordinary. There must have been some conversation about it at some level, but I don't recall any. My parents' marriage was not terrific to begin with, but David's disappearance was the end. By then, they were so wounded that they couldn't deal with each other. Their marriage fell apart pretty quickly after that.

Their divorce was a non-event for me. I was in college. It was more of an issue for Deb because she was home. I was still a little too young and too emotionally immature myself to understand the full implications of the divorce for her. While I wasn't always perfect, I did try to be more of a presence in her life, and she took advantage of that. I moved out West for a while after college, though, which was a selfish thing to do. I should have stayed.

My father died in '83, when he was 54, my mother died when she was 63, and Judy, Deb, and I became a cohesive family. As sad as it was to lose them, I think that we shed the last bit of family strife when they died. I have a great relationship with my sisters now. I don't always think it's as intimate as it could be, but it's certainly loving, loyal, and supportive.

The relationship that we have now makes me wonder what we might have done differently as children to be better to each other. What would we have been like had our parents been more able to foster closeness or to mediate our differences? They should never have let Judy and me get as confrontational as we did. But they didn't know how to mitigate our conflict or put the right spin on it. At this point, if anything drives me crazy about my sisters, it doesn't matter. I'm not inclined to care if we have differences. Our common ground is more important.

Judy, age 46. The three of us are certainly not cut from the same cloth, but at this point in our lives, that doesn't matter. We love and respect each other. We enjoy each other's company, and our get-togethers, whether on the phone or in person, give us the chance to connect and to get glimpses into each other's lives. I'm the oldest. Audrey and Deb are four and eleven years younger than I am. David was three years younger than Deb. We had another sister between Audrey and Deb, but she died after the first few days of life. As children, Audrey and I shared a bedroom. Our relationship then was multi-faceted, with both sweet closeness and friction. It was a treat when we sometimes traded beds or even slept in the same bed. But then we'd argue about whose side of the room was neat. When Deb came on the scene, I was a lot older and felt she was mine to spoil a bit. Adolescence

was hard for us. Audrey and I weren't close. I didn't understand her interests or needs. We argued some and otherwise lived in disconnected worlds. I was less fun-loving and more traditional than my sisters. I clung more closely to our mother, geographically and emotionally. When Audrey went off to college, I knew what she was up to—sort of—but that was it.

For many years, I have thought that our emotional distance as sisters back then was a failure of mine—which it may have been, but now I wonder if perhaps our parents didn't know how to help us form good relationships. They weren't able to help us find and enjoy what it was we shared as sisters. I don't know if parents can do that, but ours didn't. We had to discover this for ourselves much later.

My maternal grandmother's entire family perished in the Holocaust. We don't know how much of her anger and abusiveness was a result of a survivor's syndrome. Like my father's mother, she was a loving grandmother, but not a loving mother. Having both been raised without the luxury of warmth and love from their mothers, my parents struggled with emotional deficits their whole lives. Somehow, they managed to leave us in much better condition, and that is their legacy.

I was 20 when my brother, David, disappeared. I don't know that it altered anything among the three of us girls—we were already at such a low point of connection. Closeness and strong bonds of love were simply not part of our lives. In this trauma, we didn't turn to each other. We turned to our friends. For me, the experience was very unreal—I was there, but I didn't feel much.

Several years later, David's remains were found. With the reopening of the earlier painful wounds, I reacted with more feeling than that summer when he had disappeared. I hurt. I had much more understanding of my mother's needs. But still, to this day, my sisters and I are unable to talk about David very much—certainly not about his tragic death or about what that experience was like for us.

My parents were divorced shortly thereafter. My father died at the age of 54 in 1983, and my mother had a heart attack in 1986. She never got over the loss of David and the horror of his death. I'm not saying that she never found joy in life after that—she did, but she lived with a lot of pain. After her heart attack, she married again for six years, but it wasn't successful. When she discovered that her husband had bipolar disorder, it just finished her off. She died in 1992. I think of her often and miss her.

I think that moving out of our childhood home, and learning about different relationships as we began to define our individual journeys, made it possible for us to start coming together as sisters. As emerging adults, we felt a desire to seek each other out, to be part of each

As sad as it was to lose them, I think that we shed the last bit of family strife when they died.

other's lives. We relate to each other as individuals, but with a shared history.

Now, as an adult, I appreciate who my sisters have become. Audrey works with determination, both at her career and when fixing up her beautiful home. She has very high expectations of herself and, as she strives to meet those standards, the results are impressive. She has a great deal of flair and a unique, classy aesthetic style. She is highly accomplished, powerful, and interesting. As a sister, Audrey is loving, deeply emotional, and generous.

Deb is also an articulate, smart, and accomplished woman. She's warm, sweet, and quick to let me know that I shouldn't be so hard on myself when I fall short in trying to pack too much into a 24-hour day. She loves to give gifts large and small, and as a sister she is supportive and nonjudgmental.

They are both wonderful sisters. While I seem to have more in common with my friends than with my sisters in terms of lifestyle, the fact remains that we can know and understand things about each other that friends, no matter how long they've known us, can't possibly understand.

Audrey and Deb are on my mind a lot—they are part of my life. They are both a huge help to me as I go through my life. I have a need to be actively connected with them, to know what's going on. There's a very close feeling among us that I cherish deeply, more than I can describe. Is it our shared history? Is it our friendship? I don't know. Probably both. I do know that we truly love each other.

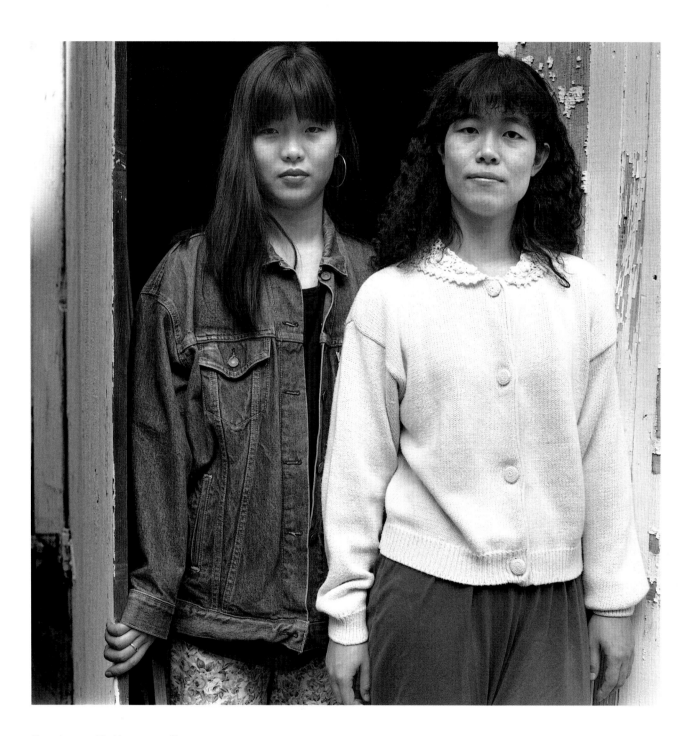

Connie, age 13 Kang, age 18

She's my most intimate confidante, my guide.

She's still one step ahead of me. **Katie**

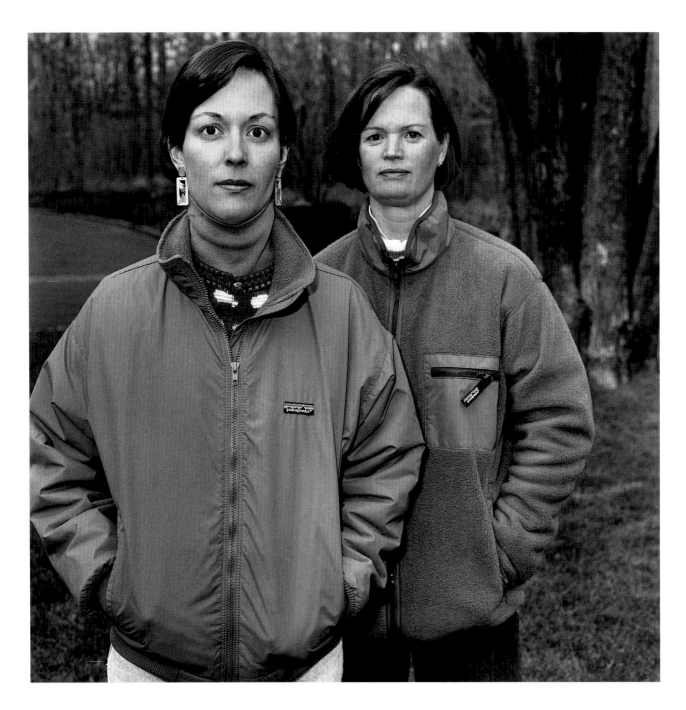

Joan, age 41 Barbi, age 47

barbi joan

Barbi, age 61. I am the eldest of six sisters, My father died in a plane crash in 1942, during World War II, when I was just 14 months old. He was a lieutenant in the United States Navy, stationed in the Dominican Republic. I was alone with my mother for four years, after which she married my stepfather, who we called "Da," in 1946. With the war just over, I went with my parents to Bermuda on their honeymoon.

My eldest half-sister, Joan, was born a year later, followed by Ann, Helen, Leslie, and Sally, with a span of thirteen years between Sally and me. With lots of babies in the house, those early years were noisy and fun. Joanie was nearest to me in age and she was closer to me in our childhood than the others were. We both loved to ride horseback, and one summer we went to a ranch in Wyoming together.

This photograph was taken right after we had a family crisis. It was a really loving time for all of us, especially Joanie and me. I learned a great deal about the dynamics of family relationships and how important the ties of our early years were in keeping us together through the crisis.

Just before Mom's death, Joanie and I alternated caring for her. It was just the two of us for a week before any of the other sisters, who live out of town, joined us in Chicago. During that time, Joanie and I not only kept in constant contact with each other via cell phone, but we also saw each other every day. It was absolutely wonderful to have one another's support during this emotional time, which brought us even closer together. As the years go by friendships become increasingly meaningful. This is true not only with Joanie, but all my sisters. I am so lucky to have them!

Joan, age 55. Because there are six of us, we were known simply as the "Behr girls" growing up. Barbi was six years older than I was, clearly the "big sister." Ann and Hooey (Helen) are one and two years younger than me and the three of us were often dressed alike. Leslie and Sally came four and five years after Hooey. Barbi was just a baby when her father died, and the fact that she had a different father was freely discussed at home. It never seemed like a big deal. As the eldest, Barbi did things first and seemed to have much more freedom than the rest of us. She went off to boarding school when I was 8.

I followed Barbi to the same boarding school that our mother had gone to, and Ann and Hooey followed me. In college, Barbi once took me to see the Hasty Pudding show at Harvard, which was a great treat for a younger sister. As Barbi married and settled into suburban Virginia, I headed west to San Francisco for college. It was the mid-sixties. By the early seventies, Barbi had divorced and moved back to Lake Forest with her two children. By then, I had married, been a navy wife in Hawaii, and moved back to Lake Forest myself. It was the first time Barbi and I had been together since we were young, and it felt good to be together.

When this photograph was taken, I had just returned to work after taking time off to raise the kids, and Barbi had encouraged me in this. Several years later, when we were the only two sisters left in the area, we also went through the changes and grief that come as parents age and die. We worked closely together during the last years of Mom's life. Since then, there have been many adjustments on all our parts, but we remain close and continue to keep in touch.

Several years later, when we were the only two sisters left in the area, we also went through the changes and grief that come as parents age and die.

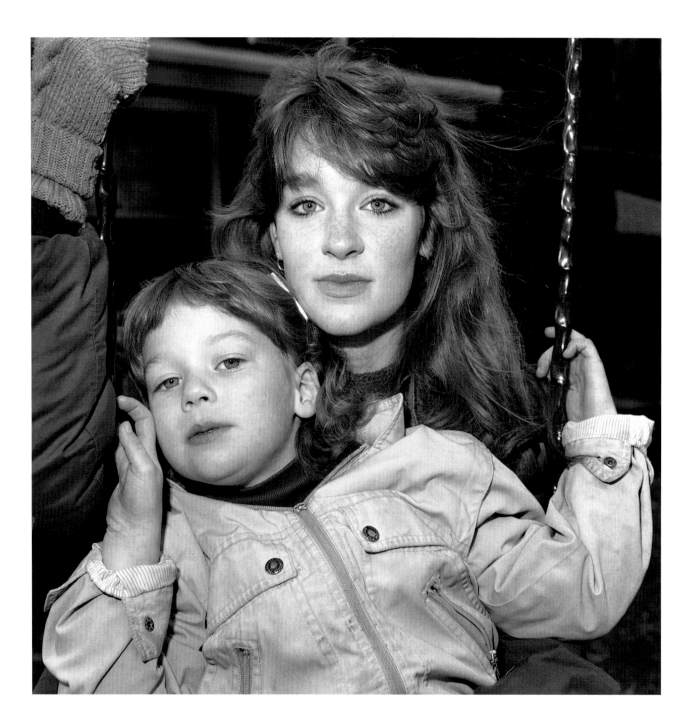

Joy, age 5 Bethany, age 16

bethany joy

Bethany, age 27. I remember so clearly the day Joy was born. I remember because when I was 11, I got my first period and my mom was missing hers because she was pregnant. I thought, "Holy smokes! I could have a baby. This could be my child." I had three brothers and I was terrified that I was going to have another one. It was about two-thirty in the morning when my parents left for the hospital to deliver Joy, and I was awake. All that night, I wrestled with God. What if my parents came home with another boy? Would I accept that or not? It had taken me a while to accept my third brother, Jeremy, when he was born! I did fall asleep eventually, but not before I was able to come to the conclusion, "Okay, if it's a boy, I will choose to love it even though I *really* don't want another boy."

My father came in at about seven in the morning and woke me. He said, "Guess what it is?" Very matter of factly, I said, "It's a boy." "No! You have a sister!" I was amazed. I was sure that I had lost and God had won by giving me another brother to teach me something, but this way, we both won, and I was unbelievably happy. When she came home, my mom and dad put her in their bed and I stayed with her the whole day. I watched her sleep. I held her. I pretended she was mine. She was absolutely beautiful, and it wasn't that she was a doll. She was just my sister. It had taken me eleven years to get her.

When Joy was little, she had lots of confidence—even at age 4. She knew that as the baby of the family, competing against three older brothers and a sister, that she had to be assertive. For example, when I was a junior in high school, she was four. I was a cheerleader and I'd teach her all my cheers. Joy was desperate to grow up like her siblings. She made up this cheer: "Pu-ber-ty! It's coming to me!" She did it in front of the whole family. I never had the guts to be so assertive. As the oldest girl, I had always enjoyed a certain respect due me.

At times, that respect came with a certain cost. Being the oldest, I felt like I had to be the one to clear the path. I was cutting down the bamboo, whereas Joy had the path cleared for her already. I was the first girl and the eldest girl, *and* I was a pastor's kid—all of which contributed to my struggles with perfectionism. I've never been quite as confident as Joy.

When I left for college, I was 17 and she was 6. I had struggled in high school, and some of my struggles continued in college. I used to write endlessly in my journal, hoping that it might serve as something to pass on to Joy—hoping that in writing it, I could somehow redeem my experience. You know, "What does it feel like to have a crush on a guy when you're 16 and then have your heart broken?" I tried to think of it as something to give her (which I ended up doing when Joy turned 16).

After college, I hit a huge blank spot. I returned to Massachusetts after having taught English in Japan for a year. I lived at home for about nine months and I hated it. That segment of my life was a kind of breakdown. For a few months, I couldn't smile. I didn't want to be touched. I had never questioned my family's love for me, and suddenly, I didn't feel loved by them. Oh, on some level, I knew they loved me, but I didn't care because I couldn't *feel* anything. I didn't want to be near my parents and I didn't want to go to church. I felt very far away from Joy.

I started taking antidepressants and began to come back. Eventually, I was able to take my brothers and sister aside and apologize, to tell them I was so sorry that I had been this way, but that I had had no control. I feel bad that Joy, who was only 12 at the time, had seen that part of her sister. I mean, they all saw it. You can't keep something like that a secret. I knew how worried everyone was for me, but I felt so powerless, so disconnected. That experience of depression led me here to graduate school to pursue guidance counseling.

Now, I feel a certain wonderful responsibility to set a good example for Joy. I am very aware that she is watching me closely. I know that if I do something challenging, then she'll feel more able to do it herself, or if I'm convinced

I watched her sleep.
I held her. I pretended
she was mine.

She was just my sister.
It had taken me
eleven years to get her.

about something, she might consider that conviction as well. I feel like I'm holding myself accountable to someone or something. I don't look to her for love and acceptance like I would my friends. I'm more sure of her love. I *know* she thinks very highly of me. I do not even think it's something that I've earned. It's just part of being an older sister.

She's different than me in wonderful ways. She is secure in herself and has grown into herself much sooner than I ever did. I remember her as a baby that I held in my arms and now, the Joy I see is this tall, beautiful woman who looks like a model. All the boys have crushes on her. She has bigger breasts than me, and she's not even 16. I can't imagine a time when I won't be close to Joy. I don't know who she's going to be, but I'm excited to find out. I think she can do just about anything.

Joy, age 15. My sister is a great woman of God, and I definitely want to be like her. My father is a minister, and we grew up in a family that was very close, loving, and faithful. I wouldn't say religious, necessarily, but very trusting in God. Bethany is so wise and independent, but she also depends on God to show her where to go in life. I have so many doubts and questions about my faith, but I know I can always go to her and my family. The Bible says that everything works for good for those who love God, and I know that Bethany loves God so much that everything will come together for her. Even though she doesn't know exactly what she wants to do in life, she seems like she's on a path, and she seems very comfortable.

I don't remember all that much from our childhood because I had just turned 6 when she went to college. We really didn't hang out, but I knew she was so happy to have a little sister. When I was 12 or 13, and I began to mature, our relationship changed, and we became closer. We were able to share clothes, and she would teach me how to use makeup. Now, at 15, I have great relationships with all my siblings, but especially with my sister. I'll admit that I don't tell her everything, but I go to her for advice about family, girl or guy stuff. Even though the advice she gives me isn't always what I want to hear, I trust her maturity. She levels with me.

We talk about our differences sometimes. She's the oldest and she had to grow up at a younger age than I did because she had all those siblings looking up to her. Bethany did ballet and gymnastics, and I played basketball, soccer, and any other sport I could. I grew up with three older brothers, and I was and am much more of a tomboy. I'm tougher—not necessarily stronger, but tougher. She's more graceful and certainly sweeter to my brothers. But then again, I feel like I know them better. She never had that. Many of our differences come from where we are placed in the family.

I think she would say that I have it better than she did. I don't think she would use the word "spoiled" (although I am), but I did have a path made for me. When I went to high school, people already knew me through my sister and brothers. Bethany had to make her own way and she was very shy. On the other hand, when she left for college, I was left there to fend for myself—one against three. It was hard. Sometimes, I'd be so angry with my brothers, and I'd cry because I wanted my big sister around, and she wasn't there.

Our relationship is "in the making." We worked together at a camp this summer, along with two of our brothers, and it was amazing. Bethany and I saw each other every day. She started to see a guy there and it made me feel so good when I was the first person she'd share her secrets with. She even asked *me* for advice. I felt so special that she considered me her confidante, that she trusted me. Once in a while, she'd leave me encouraging notes about a conversation we'd had, and it meant so much to know that she was thinking of me.

Our relationship isn't perfect, but it's really good. Sometimes we get frustrated with each other over little things, like how messy I am. And I wish we were closer in age. We might fight more, but she'd feel more like a real sister to me. I want to be able to call her up and ask her to go to the mall. I would love to be her best friend. But the age difference will make it hard.

We all feel a lot of love in our family. My mother taught us what it means to be a mother. My father is the wisest man I know. My brothers are amazing, and Bethany teaches me, all the time, what it means to be a sister.

She has bigger breasts than me, and she's not even 16.

I felt so special that she considered me her confidante, that she trusted me.

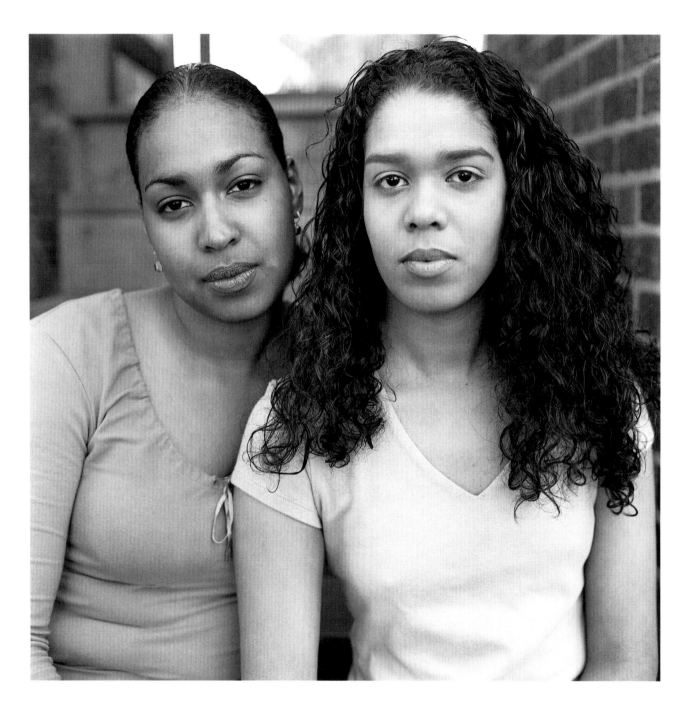

Beatriz, age 20 Sara, age 21

beatriz
sara

Beatriz, age 20. We didn't have much as kids, but Sara and I were tight. When it thundered, she'd sleep in my bunk. When I was scared, she'd keep me company. We had a lot of fun, and it really felt like we were sisters then.

When I was about 13, we stopped hanging out together. I was a wild teenager—drinking and partying, taking stupid risks. At some point I knew that if I went any further, I'd be in a world of shit. I never wanted to bring Sara into all that. In a weird way, I was trying to protect her.

Sara started partying suddenly on her own. She got scared fast and thought she needed help. My mom got her into a program. I thought she was just experimenting. But maybe I don't know her as well as I think I do. It can take her a long time to tell me the whole truth about something.

I got pregnant when I was 18. My parents were mad, but Sara was excited to be an aunt. When things didn't work out for Vito's dad and me, I came home. I got a job so I'd be out of the way, and Sara babysat him. She's really good with him. He even called her Mom for a while. But it was too much for him and me, so I stopped working. And now, I'm not a big deal anymore.

I feel like I'm the older sister, even though technically, I'm not. I grew up quickly, and now that I'm a mother, I know what I need to do, but I'm not free yet. My sister is still free. I tell her to get going, to finish her GED and move out into the world. But she has a lot of fears. Maybe she has her own reasons.

When she was younger, something bad happened to Sara. She told me and my cousins when we were kids, but we just kind of laughed it off because we didn't really understand. When she was a teenager, it started really bothering her and it all came out. The extended family is all split up. I felt like I had to choose sides to stay loyal. Sometimes, I don't know what to do. I feel really torn.

Fighting with Sara is a trip. She barrages you with a bunch of opinions. You can never tell her she's wrong. I may get defensive and hard, but I still hear her. I wish Sara could trust me more. She's my sister. I really love her and I want good things for her. And God, she makes me laugh!

Sara, age 21. As kids, Beatriz and I used to wake up in the middle of the night and sneak up on my dad in the living room. We'd crawl behind the couch, and then suddenly . . . he'd catch us. We'd run screaming and laughing back to our beds and pretend we were asleep.

Although I'm the oldest, I act like the youngest. I'm the goofy one dancing around the living room. Beatriz was born with attitude, and I'm a little sensitive. She really goes for it, where I'm shy of certain things—like driving. She just went around the block a few times with my father and boom, got her license and a car.

When we turned 15, she found new friends and I got jealous. She left me in the dust. I worried about her and I didn't approve of her friends. Eventually, I started partying, too. Maybe I was doing it because she was. But we never did it together. She went first and then me. It got out of hand for me, so I stopped. What made me quit was my sister and my immediate family. They're all I have. Beatriz stopped when she got pregnant.

We're both *hopelessly* in love with that baby, but we conflict over parenting. Sometimes I think I have a better way, but my mother reminds me that Beatriz is the mother and that I have to respect her ways of raising a child. But it's like she's the husband at work and I'm the housewife, except I don't have any say. Sometimes, I'd like to be the older sister—just give her a little advice—but she feels offended and we end up arguing.

I wish we were closer. I think things will change for us when we're not under the same roof. I'll have a little more control over my own life. But for all of our conflicts, we still have good times. One Fourth of July, she and I took the bus downtown, walked to the lake, and watched the fireworks together. It was so beautiful just to be with her. I still love to make her laugh.

It can take her a long time to tell me the whole truth about something.

Sometimes, I'd like to be the older sister— just give her a little advice—but she feels offended and we end up arguing.

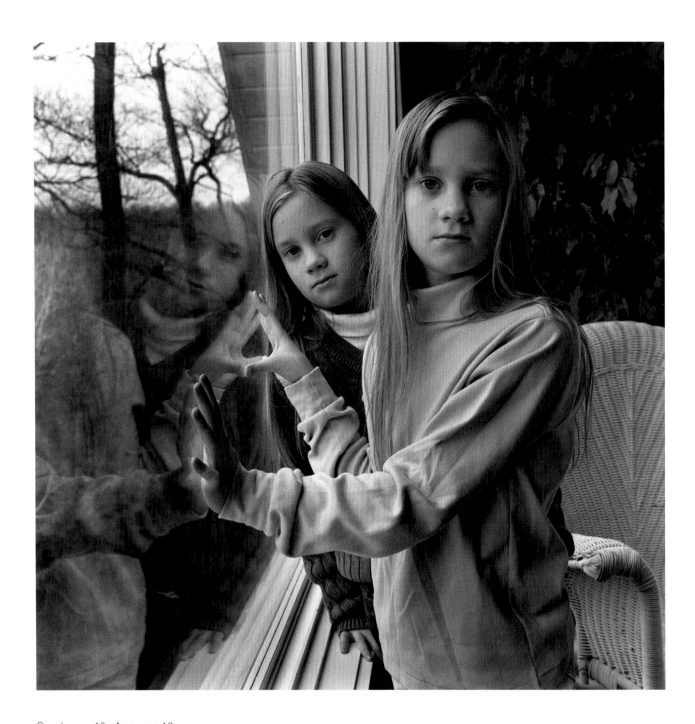

Sarah, age 10 Ann, age 10

sarah
ann

Sarah, age 20. At the time of this photograph, Ann and I were all about expanding outside of each other, outside of the whole idea of sisters. We had been so close for so long, and we never thought twice about it. Suddenly, we were choosing different sports, different friends. There was a jealousy thing. She'd become part of a crowd that I wanted to join, and I'd think, "Oh, no! She's got them all." We didn't feel we could have any friends in common. My sister ran with the popular group, whereas I chose more offbeat friends. I was the rebel type. She wasn't. We didn't talk about everyday stuff because we didn't have to. We already knew what the other was thinking, and we wanted to ignore it. We didn't want to be the same.

We've come to think less about our differences. The other day Ann and I were sitting quietly together in the same room. It made me think about how authentic a relationship between two people can be. I feel truer to myself when I'm sitting with my sister than when I'm not, because she knows me. In her presence, I don't lie to myself about things. I am recognized in a really deep way. Even if I'm not thinking about her directly, she's always in the back of my mind. We shared a womb together, and we just intuitively know each other's needs and reasons. We can sense each other.

We have a lot of different characteristics that indicate that we're fraternal. But if someone told me that we weren't identical, I would think they must be wrong. We've spent so much time trying to differentiate from each other, but we're just coming to realize how integral we really are to each other. It's an incredible journey, living my own life and yet living a part of hers at the same time. We are truly interdependent. When we come back together after a long time, it's like we tap into the most pure feeling in each other's company—feeling that isn't about words.

Ann, age 20. As kids, Sarah and I would scale up rocks and steep hills together. We felt like we had conquered the world—just the two of us. We were wide-eyed and loved reading. We played soccer down the back hill with my dad. We rode the school bus together. We did everything together.

Around the time of the photograph, we wanted to be our own people. It was hard because we liked the same things, had similar talents, and gravitated towards the same people. We started to compete over grades, friends, and sports, but it never turned into rivalry. In some ways, the competition helped us succeed academically. We chose different friends, different sports. They were opportunities to differentiate.

We're both committed to being sisters. There is an unspoken expectation that we will make lots of space for us to be with each other. We need to spend time together for our own well-being. Otherwise, it feels like something is missing, something isn't quite settled. It's not some mysterious twin thing, just a powerful bond formed over the years. I don't have to do or say very much in order to communicate to her what I'm thinking and feeling. With her, I feel permission to become more myself.

Sometimes such a strong bond can interfere. I can start feeling like parts of my life aren't my own. For instance, she has a serious boyfriend, and it's hard for me to understand how she could be so close to marriage when I don't have anybody. It's as though *we've* been the couple, and now she's cheating on me. It's hard not to feel like I'm getting behind or I'll be left behind.

Our separation from each other during college marked the end of us as child sisters. We feel more like friends. Our experiences were different enough so that we didn't have to compare. We've reunited and decided to live together this summer—probably for the last time. No matter what, wherever *we* are, for me, is home.

We need to spend time together for our own well-being.

I feel truer to myself when I'm sitting with my sister than when I'm not, because she knows me.

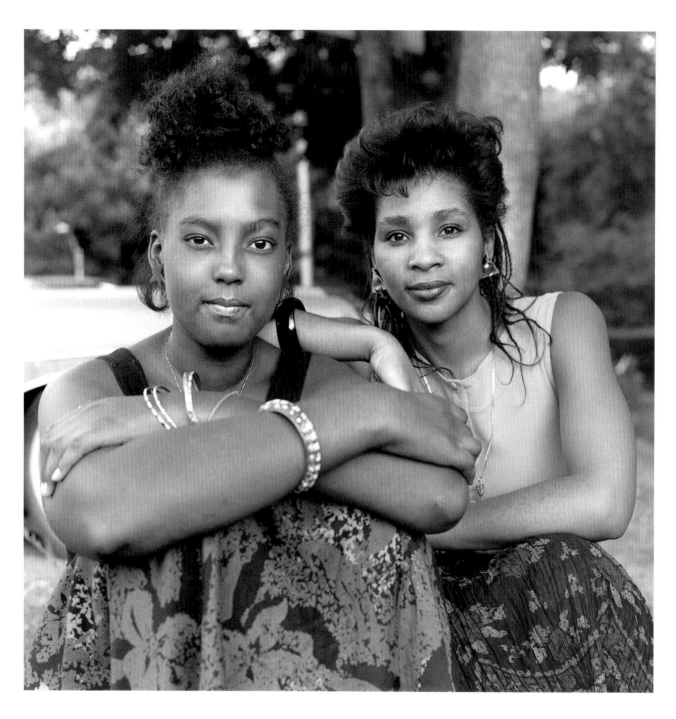

Amy, age 12 Sheryll, age 29

sheryll
amy

Sheryll, age 41. Sometimes it doesn't feel like I'm an older sister. It even feels funny saying it, because we're not connected the way we should have been. Our life circumstances gave us neither the skills nor the opportunity to be sisters. Even now, though, we both try the best we can to connect, but it's challenging because I'm not there and she doesn't feel comfortable confiding in me. We don't have one of those relationships where you process the relationship itself, because when we start doing that, feelings get hurt and tears come. There's a lot between us that has never been spoken.

There are six of us altogether. I have two older brothers and then a younger one. There is another brother, and then Amy, who is 25. The first four of us have the same mom and dad. Amy and her brother have different fathers. I was in college when this photograph was taken. Amy was visiting for the week. I wanted to do something special with her.

Growing up, I was close with my three brothers. My mom got pregnant with Amy when I was 16 or 17. I was really happy because I had always wanted a sister. It was also a challenging time because my mother was older, and it was a really difficult pregnancy. When Amy came home, it was a lot of work for us. It was my brothers and me getting up in the middle of the night getting bottles ready because my mom was recuperating.

My mother had her own issues at that time, and I felt that I needed to leave the house, so I moved in with my aunt across town when I was 17. I only lived with Amy for about a year. Even though Amy and I were living in the same town, we lived different lives. We weren't connected at all. We didn't have anything in common. I felt badly that I wasn't there for her more, but I needed to find my own way. There was absolutely no nurturing for me at home. I went to Westfield State College and studied social science. I went home every weekend, but to my aunt's house. I'd pop by my mother's house and see Amy, but just briefly.

My mom suffered from mental health issues. Her first episode was when I was 3 or 4. My father was an alcoholic, and he used to abuse her. We're not sure if the abuse triggered more of the mental illness. I can remember when I was 5 or 6, my father was trying to put my mother's head through the window. I can remember the room, my brothers trying to stop him, and the police. Back then, the cops would make him leave, but he'd be back the next day. I can't remember very much about my father, but what I do remember is not good. Just drinking, drinking, drinking, and abusing my mother. He left and moved back to North Carolina when I was 7 or 8. I was devastated. I saw him a few times after that when I'd go to visit my grandmother in North Carolina, but I was very uncomfortable. I didn't know him or why he drank. I didn't care what people said, I didn't want to be connected to him. I felt like he abandoned me. Amy never knew him. I never knew Amy's father, either. I don't think Amy stayed connected with him. I think Amy always felt that my brothers and I treated her differently because she had a different father, but that's not my perception at all.

I remember being a little kid and my mom having episodes. The ambulance would show up and so on. My Aunt Jean would take us in and say that my mom was sick and needed medication. But I never really understood her illness. My Aunt Jean was always there to cook for us and to make sure our clothes were clean. She always helped my mother. And there were times when my mother was okay. I remember what she used to be like . . . before. By the time Amy and my youngest brother came around, my mother was sicker. Aunt Jean was older and struggling with diabetes. She couldn't really help as much. Amy never had a mother who was healthy, whom she could do things with. No one ever sat her down and explained anything to her about our mother's illness. She just kind of grew up in it. It must have been really frightening for her. It was for us.

Our life circumstances gave us neither the skills nor the opportunity to be sisters.

When Amy was about 9 or 10, she went into a foster home. One of my brothers had taken her in at one point, but she was very angry and rebellious, and it hadn't worked out. It wasn't an option for me to take her in at that time because I lived on campus. I didn't have a steady household. I was going to college and I had joined the army to help pay for college. I was in the National Guard for nine years. I had to be very resourceful. There was no support coming from either my mother or my father. I think Amy resented the fact that I had gotten away . . . that I didn't rescue her. It was a tough call, but I did what I had to do.

I helped her get into Westfield State College to study early childhood. She really loves children. I would pick her up on the weekends and bring her to my house. I was really trying to reach out to her—you know, doing for her. But we weren't compatible. We had different up-bringings and generational perspectives. Our ideas about what was acceptable behavior and how to do things did not mesh. We'd argue, have words, and both leave in a rage. After a year and a half, she went back to Danbury and lived again with my mother. Even then, we got into arguments about my mother, and she would be like, "Who are you to tell me what to do? You're not here." And that part was true; she was all alone. When she gets angry, it's hard to calm her down. But then, I have to remember that she's probably dealt with a lot of situations that made her angry, and there was no one to guide her or help her in her anger.

Still, we both persist in trying to find our way to each other. When I go home to Connecticut, we make a point to see each other and talk. She's very close to my 10-year-old daughter. When I got married a few years ago, she bought the arch that we walked through, and I made sure we took pictures together. Just this last Christmas, we took my mother out of the nursing home for a few days, and we were able to work together to do all the things that needed to be done to care for my mother. It was really nice.

My brother made the decision to put my mother in the nursing home last year, and Amy is keeping the apartment. She has more freedom from the big burden of caring for my mother. She's so young to take on that responsibility. On the other hand, she also has diabetes, and I worry about her. She manages pretty well, but she still has episodes that land her in the hospital. I tell her to call me if she needs anything, but she won't. Maybe she just feels like she can't count on me. It is not the perfect sister connection.

I think in the right situation, she can become a productive person. She has many good qualities. She's very friendly and outgoing. No doubt the trauma in her up-bringing has been a hindrance to her growth. Maybe I was a positive model. I know she respects my work as a case manager in a correctional facility. But she resented me, too. She needed a mom, a loving adult who could function, and she never really had that. Sometimes when I think about her life, I feel sad and bad about it. I feel powerless.

Amy is teaching me to take the time to understand different perspectives and to learn how people can grow up in the same family and experience two completely different lives. The older I get, the more I understand her position. At least I had my brothers to talk to. She gives me a better understanding of how growing up can form your personality. Sometimes when I reach out to her, it feels uncomfortable because we don't really know what our connection is. We're not together every day. We're not in the same town. But we make the effort to feel each other out. Deep down inside, I know we're family.

Amy, age 23. There are seventeen years between Sheryll and me, so we did not grow up together. In my early years, she was in college. She'd take me for a week during the summer, or she'd come through town for a brief visit. So I knew who she was. When I was 10 and 11, just before this photo was taken, I developed some serious health concerns. Sheryll would pick me up and try to understand what I was going through. I knew she was concerned, and in that sense, she felt like my older sister. Sometimes I wished that she had been there more, to help me grow and to teach me things. My mom was older when she had me. She was dealing with her own mind, and sometimes she couldn't care for me. She always cared for me the best way she could.

I have good memories of my mom taking me for a ride in her nice, big, green Cadillac or dressing me up and doing my hair, but my mom was ill, and it got serious very early. My mom is schizophrenic, and I didn't really understand what that was about. No one ever sat me down to explain it to me. My brother Robin and I just figured out on our own that our life wasn't normal.

My mother used to talk to voices. Most of the time, she'd talk about my older brothers, about Sheryll, and about her first husband. She would repeat some of the things that they had gone through, like fights and heavy drinking. That's how I know that their father was violent with my mother. My mother got progressively worse—more and more episodes—as I got older. Eventually, I was removed from my home and put into foster care.

The defining event happened when I was about 8. It had been my first day of camp, and I had come home so happy and excited. I couldn't wait until camp came again the next day. I remembered that my mom had all these sleeping pills out on her dresser. So I took I don't know how many of her pills and overdosed. I regained consciousness twice over the next several days. The first time I came to, a neighbor was carrying me in her arms

to her house. A couple days later, I woke up in the hospital, and Sheryll was standing there. I'll never forget seeing her there. It really moved me. My mother followed me into the hospital with a nervous breakdown, so they would wheel her down from the psychiatric ward to visit me on the children's ward. I celebrated my ninth birthday in the hospital.

For six months of my ninth year, I was in foster care a half-hour away from my mom. And then I lived with one of my older brothers and his family until I was 14. I didn't particularly care to live with him, as he and I had already had a history of violence. Living with a family member was the best way for me to be close to my mom. He lived in the same town. At that point, there was no chance that she would get me back.

My brother struggles with his own issues, and you never knew what to expect. One minute, he could be a really nice person, and the next minute he could become very abusive. Don't get me wrong, he's a very hard worker. He always had jobs. He always provided, but he was abusive—not toward his wife or his kids, but to me. I don't know what he endured during his childhood, but I believe he thinks that it was my fault that Mommy was sick. By the time I was 14, I was really fed up, and I started fighting back. I went back into foster care and was trying to claim my emancipation at 16. I was granted my rights to go home to my mother, and I've been there since. The last time he and I really fought was when I was 18. During those years, a huge reservoir of anger and animosity grew between my brother and me, and it still exists. I'm trying to deal with it because I'm very attached to his kids.

I don't think Sheryll was aware of what was going on. She was pretty busy with her life. She was in the military, and I would hear that she was traveling to places like Italy. I always remember that if she brought someone home, it was always a nice-looking man with a nice car and nice clothes. She was from the outside world, and she always looked good from where I sat. We didn't have the type of relationship where I could just tell her anything.

Sheryll and I started to talk a bit more when I was in high school, but it was mainly about the conflict between my brother and me. She was the go-between. I was really angry, and I felt like she was always hearing one side of the story from her brother . . . her full-blooded brother. I felt like she was never looking at the reasons why I did some of the things I did.

Nevertheless, Sheryll helped me get into the same college that she went to. By moving near her, I hoped to build some type of tight-knit relationship with her. It didn't work out that way, because she had a child then. Her child needed the attention I was seeking from her. She was supportive, but from a distance. I was angry about it. Perhaps things might have been different if we had connected earlier.

Mommy was also getting sicker. She'd be in the back yard hanging the clothes on the line when her legs would give way. She had to have surgery on her back, and she was basically gone for a year. I was 17 and taking care of myself. I worked in a grocery store and then a day-care center, and I was going to school. I remember getting a big tree for Christmas, hoping they would let my mother out before Christmas, but they never did.

I studied psychology and elementary education at college for two years. I came back to Danbury and completed a year at a nearby university, because I was concerned about my mother and I was struggling with diabetes. My illness set me back in school, and I became unable to care for my mom. My brothers decided that she needed to go to a nursing home. I'm not happy that she's there, but I feel she's safer. It's a big burden off me, and I can continue to work and go to school once my health improves.

I've never had the chance to talk to Sheryll about what happened to her as a kid. I've heard things, but I don't even know if she wants to bring back those memories. I feel like if I say that I had it rough, then they're going to say that they had it rough, too. Like who had it worse? It's something that still separates us. Her daughter is probably what connects us the most.

I love my sister. She wasn't around to help me go through things, but I don't blame her for that anymore. She needed to make a life for herself, and she did: a career, a beautiful family, home, car. Sheryll is a hardworking, strong, independent woman. She's one of those women who did for herself. She finished college. She was in the military. She is structured, disciplined, and focused. She knew what she wanted, and she got it. I'm very proud of her, I admire her, and she inspires me. I'm a different kind of person because it was my responsibility to care for my mom. We may never get as close as I want us to be. But I'm happy with the relationship that she and I have now. I know that if I need her, she'll be there for me if possible. I think she and I are going to be okay.

I've never had the chance to talk to Sheryll about what happened to her as a kid.

She was from the outside world, and she always looked good from where I sat.

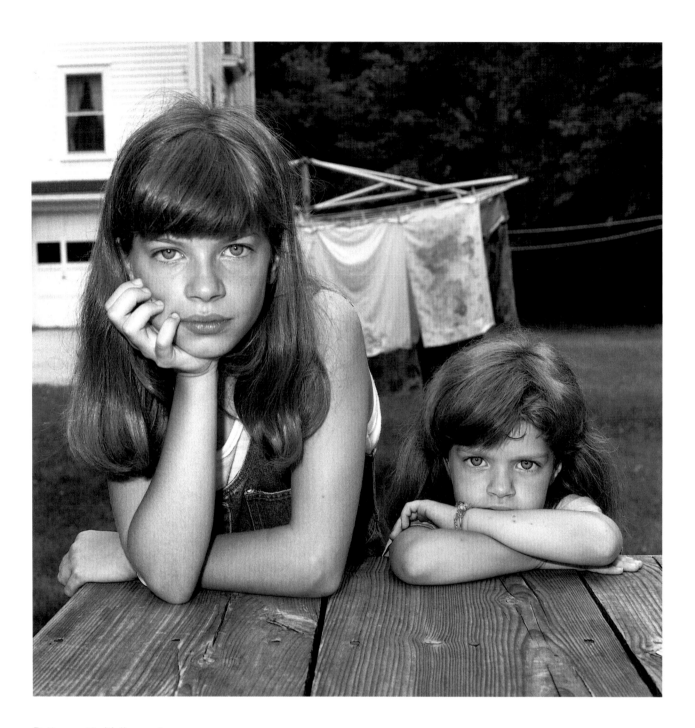

Beth, age 10 Molly, age 5

beth
molly

Beth, age 21. I really love my sister, Molly. When we were younger, I was the responsible one, the one who made sure that the dishes were done. I never got in as much trouble as Molly because I learned how not to push my parents' buttons. Molly's role was to be cute. She was always hanging around, wanting to be included. It was kind of annoying.

When this photo was taken, I was 10 and she was 5. The age difference was too big, and we didn't really play together. In high school, I was just plain difficult, and I didn't talk with Molly or my brother, Jacob, except to tease or bicker with them. But when I went to college, she and I grew closer. Now, when I'm home, it's special. For a while Molly thought I wasn't cool, but now she doesn't really mind me.

Molly and I are like right brain/left brain. She's incredibly creative. She loves art and cooks without recipes, where I'm a strictly Kraft Macaroni and Cheese person. She's a maker and I'm more bookish. I study biology and plan to become a medical missionary so I can combine my love for medicine with my love for God. Although those things are not Molly, I think she appreciates that part of me.

Faith was just woven into our family's fabric. My parents have always been very involved with the church, and I'm a very committed Protestant Christian. I'm more outward in my faith than Molly is. For a while I was concerned because it seemed like Molly was rejecting the whole thing. But she seems to be taking more ownership of her belief.

During vacations, Molly and I are girlfriends—hanging out, talking about boys, driving around, listening to music, reading cheesy magazines. We watch corny teenybopper movies and go shopping—slumber party stuff, but *our* stuff to do.

Having younger siblings has made me more responsible and considerate of others. I learned how to share love and things. Although Molly and I don't stay in constant communication, I can turn to her—especially about family issues. Because she's so accepting, I can be more truly myself. And she can love me, too, without feeling as though she has to follow me. I love her unfolding.

Molly, age 17. I always liked being the youngest—less responsibility and always someone else to blame. I'm sure it was tough on Beth being the role model. She was the "good kid" who stayed out of trouble, got good grades, and did what she was supposed to. I don't get good grades, and I always got in trouble.

She was so much older that we never really hung out. We weren't close until she went away to college. I'd visit her there without my parents, and we'd see her friends or go shopping. Just being older gave us more in common.

Beth had a lot of problems with peers when she was in high school. I remember her being really upset all the time, but I wasn't old enough to talk too deeply about it. It made me a little nervous about going to high school. As she confides in me more about her experiences then, I am amazed by what she has overcome. I think she's brave and strong. I also realize that she and I are so different that I probably won't have to deal with some of the things she has. She's athletic and smart, but she doesn't have the interest in art that I do. I'm a little more well rounded, outgoing, and materialistic than she is.

Beth has a great heart. She is focused and serious about what she wants to do as a medical missionary, but she has a fun side, too. She has her life on track. It's cool because I've seen a lot of kids who just float around without knowing who they are. Beth seems to. She makes me want to be like that—responsible for what I do. We never really talk about it. It's just understood.

We have a tape of several songs that are "ours" that we blast when we drive around together. For my sixteenth birthday, Beth made me a CD of all of our songs. I love having that with her.

I always liked being the youngest— less responsibility and always someone else to blame.

For a while Molly thought I wasn't cool, but now she doesn't really mind me.

Sally, age 21 Rosy, age 25 Kathleen, age 30 Susan, age 27

sally rosy kathleen susan

Sally, age 32. I was the youngest of four sisters, "the baby." I was also a tattletale and a brat. When my oldest sister, Kathy, hit puberty, I was the first to announce to the neighborhood that she wore a bra. It didn't go over well.

Kathy is eight years older than I am. When we were growing up, she was nice but she was busy with her own friends. Susie, who is six years older, was nicer than the rest. She was a real caretaker, and she'd do things like watch Sesame Street with me. Four years older than I, Rosy and I battled it out. We shared a room and it was awful. At bedtime, she'd yell across the room, "Don't move, you're making too much noise. I can't stand you breathing so loud!" And I'd have to lie perfectly still. We did manage, however, to have a lot of fun together.

When I was a teenager, there were certain things I knew not to tell my sisters . . . about boys or staying out late, for instance. They were watching out for me, and I knew they would tell my mother. There were plenty of reasons for them to be worried about me, but then again, there were reasons to worry about all of us. As the oldest, Kathy was always in charge, but Susie and Rosy never wanted to listen to Kathy, so there was always something to argue about. As the youngest, my opinion didn't really count until I was in my 20s.

Susie got married first, but I was the first in my family to have a baby. I was 19. Everyone was so excited and supportive. Kathy and I were actually pregnant at the same time, but she lost her baby when she was nearly six months pregnant. She had to deliver the baby stillborn. It was terrible. She had a hard time being around babies after that, except for my Charlotte . . . She was really good around Charlotte. I didn't stay with Charlotte's father for long. My sisters saw me through all that.

A few years later, I met my husband and followed him here to Southwick. Most of his family is here. My sisters all ended up together in South Hadley. They see each other daily, but they get on each other's nerves.

Sometimes they're closer to one than the other, but I feel close to all my sisters. Though I wish at times that I could be nearer to them, I think the little bit of distance keeps my relationships more steady. I talk to at least one of them every day. My sisters feel sorry for me because I have an autistic child. They're more careful with me sometimes than they are with each other, but I don't mind not being picked on. I really do have extra work to do on the planet.

My stepson, Patrick, is 12. My daughter, Charlotte, is 11. My son Cory is 7, and Nathaniel, my youngest, is 5. It's Nathaniel who is autistic, and he's a lot of work. He wants his needs met immediately and he's very demanding. He doesn't talk, but communicates through pictures instead. He's not aware of traffic and he seeks high places, so I'm always running after him. He takes up a lot of my time, and it's a constant struggle to balance that with making sure the other kids have enough of my attention. My sisters are very helpful. Two weeks ago, they all took turns watching him for the weekend so that Paul and I could get away. They slept over at my house. I'm really grateful for my sisters because it's extra support . . . you know, someone to talk to, and I don't feel so isolated.

Having kids was a major turning point in all of our lives. It changes your relationship with your sisters. We've all had some real challenges bearing and raising children. Kathy was really committed to having a child, and with a lot of work and heartache, she finally had Brandon. Susie has twins and Rosy has two kids. It's weird to see everyone getting older. You watch each other age and you realize that you're not going to live forever. Having kids brings reality into the picture more. The thing about sisters is that you've shared everything growing up and they know you inside and out. You're also the same sex, so you know what it's like to be a woman. I don't think there could be anyone closer.

When my oldest sister, Kathy, hit puberty, I was the first to announce to the neighborhood that she wore a bra.

Beatriz, age 19 Gladys, age 17

And yet, we're all we have—one another—
so I also feel a sense of loyalty . . . forever. **Cynthia**

Heidi, age 27 Christina, age 30

heidi christina

Heidi, age 37. When I was 20 and Christina was 22, we took a trip together to see the Palladian villas in Italy. The first night, we stayed at a little farm that belonged to the family of my friend Paco. It's like a movie. In the kitchen, there are these two strikingly beautiful women—Paco's mother and his aunt—one with this long, fat, gray braid. They have these faces of integrity and strength and beauty. One woman is making aioli with the mortar and pestle: grinding each clove, stirring each egg yolk—measuring out drops of olive oil from their own groves. The other woman is making this incredible hot chocolate that she's been stirring, you're sure, for an hour. Then we have this meal: aioli, vegetables, meat, and cocoa. Meanwhile, Christina and I don't speak to each other the entire meal. We've had some fight in the car. I don't even remember what it was about, but smoke is pouring out of our ears as soon as we arrive. Here's this lovely family—hearts of gold, salt of the earth, intelligent, psychologically savvy. We don't speak Italian, but they get it pretty fast. The next morning, the mother comes to us, takes us both by the hands, and forces us to march around the house and the garden saying "pace, pace," which means peace. It healed us somehow. Christina and I both talk about that. I think we've both used it when we've had to make up with each other.

As kids, we fought a lot about stuff and power. I'd pull her braids, and she'd sit on me. I bit her once, and she still claims to have a scar. I'm not convinced. The older/younger division was more important then. She liked to be the boss and tell me what to do. Sometimes I would give in, because it was easier than her getting really upset. Other times, I'd fight back. I'd be mean with my tongue, and she would get furious. And then she would try to upset me, and I would let it roll off my back. That made her even madder. I still do it. I can be very provocatively reasonable. The more she loses it, the quieter I become.

We went to separate boarding schools for high school, so we didn't really live together anymore, but on vacations, we hung out with the same social crowd. We spent a great deal of time getting into trouble together.

When I was 28, we lived in the same city for a couple of years. She was going to architecture school, and I was getting my Ph.D. in clinical psychology. You'd think they'd be fairly equivalent programs, but our personalities are really different, so they weren't. She always felt like she worked a lot harder than I did. I'm not a perfectionist, and I really like to have free time, so I just get things done. Christina is really focused, and her work consumes her. She's extremely competent. She has always accused me of being sort of a slacker, and I always thought she took things too hard.

And then, of course, there was the marriage thing. She hasn't always had the best relationships. I think she sells herself short. She has this fantasy about my life—that I have an appropriate husband, that my parents love his parents, that he's cute, that he's whatever. She thought I had the perfect everything. That's been a theme for us . . . that my life has been a little easier than hers. I would have agreed until I hit infertility. At that point, things had to shift for me because I was tired of feeling guilty about having it easier. Up until then, I was really invested in what I could do to help her.

Infertility was the first time I didn't have any control. My marriage was falling apart. I wasn't getting what I wanted—and I had always gotten what I wanted. I went through four rounds of *in vitro* fertilization. Christina was supportive, but I didn't have any energy left to help her. I realized it was her life. She had to make her own choices, and there was nothing I could really do about it. It's challenging for me because I like to meddle. Christina doesn't really meddle. She's much more internal.

About six months ago, we adopted our baby girl, Maya, from China. She's 14 months old now. When I got the baby, I suddenly became a lot less bristly. Christina fell in love with Maya, and that made me really happy. I didn't hang around the two of them too much. I gave her

She thought I had the perfect everything.

a lot of space with my new daughter. She's really glad I have a daughter, and I think she'll be a great auntie. My parents were a little weird about the adoption, but I could always complain to Christina. She was very supportive, but also, she would say things like, "Oh, I'm just going to be the spinster daughter who ends up taking care of the aging parents."

In the last couple of years, Christina's life has been pretty tough. She has one or two really tight girlfriends, and one of them was killed in a plane crash. I tried to give her a chance to tell me what was going on and left it up to her to use it or not. It was such a huge loss, and there was so much grief that she got really clinically depressed — and she was trying to work. She would say to me, "I don't have time to see a therapist." But because I *am* a therapist, I was like, "Fuck you, that's lame."

I have more of a sisterly relationship with some of my friends than with others. By that, I mean there's kind of an underlying assumption of loyalty and love, but there's going to be times when we're not nice to each other. I can be nasty, but then I can also ask for forgiveness. That seems more sisterly. In a way, it's more immature. I have other friendships that were established when we were more psychologically mature. We're better at being clear from the beginning. It's easy for Christina and me to fall into old bad habits with each other. Now I try to take risks with Christina in terms of saying what I'm really thinking. I'm trying hard to make it funny and forthright between us.

She's so different from me. She's not as motivated by relationships. She has really high ideals for herself, for her work and achievements. She doesn't cut herself much slack. I think it's hard to be that kind of person. I'm really curious about what's going on with other people and nourished by my relationships with them. I want to make connections. Being a therapist is the right job for my interests. But maybe I *think* Christina is lonelier than she actually is. Maybe she doesn't need as many people as I do. Sometimes, I even think I'm older than she is—maybe because I have more self-control or because I'm less moody. That makes her mad. I think there's sort of an assumption that the older one should be more in control.

The idea of being estranged from Christina just doesn't seem possible to me. When I hear about siblings that are estranged, it just pains me. I know there are always circumstances in which it's the best thing to do, but in my case, I can't imagine it. Family loyalty is really critical to me. With Christina, there's a lot of opportunity to see my role in the family reflected in our relationship. Sometimes I push to be more myself and less of a child with Christina. That challenges me to be more honest. No matter what, we're in it for the rest of our lives.

She was going through her letters, and she found one about my "renting" her my Lanz nightgown.

Christina, age 39. There are four of us, two sisters and two brothers. My brother Bill is a year younger than I am, and Heidi is two years younger. Frederick is ten years younger. Even though I'm the oldest, Heidi was always the first to do things like have her own apartment, get married, have her own house, become a mother. She even got the furniture first. I remember being mad at her around the time of this photograph because she was taking all this nice old furniture from my parents' house and moving to Seattle with it. I had just moved to Boston for graduate school, and I was also upset that she was moving away. After many years of living far away from each other, it had been great to be living in the same city.

Heidi and I have always been very close; at times both best friends and best enemies. We shared a room growing up, and initially, she really did look up to me and would do whatever I said, but she soon caught on. So I tried to trick her. She was a real slob, and I hated how messy our room was. I invented a game called "king and slave," and Heidi, of course, was the slave. That's basically how I got her to pick up the room. It didn't last very long.

We grew up in Middletown, on the campus of Wesleyan. The three of us older kids played together earlier on. Heidi was the baby until Frederick came, and then she had to give up that title. He was of a different generation. Heidi and I were close enough in age that we had the same friends, and as teenagers, we spent even more time together. We were wild—much more so than my brother—going out to parties, sneaking out of the house, hanging out with the less desirable elements of Middletown, all that stuff. But Heidi fared better. She always liked herself a lot more than I did. She wasn't shy and had a lot of confidence. She always had boyfriends. I didn't. It was hard for me. At the same time, I had a really good friend in my sister.

For high school, Heidi went to boarding school at Hotchkiss, and I went to Choate. I hated it at Choate, so I would come home often on the weekends. I don't think Heidi liked Hotchkiss, but I think she had a better experience. She was going through her letters, and she found one about my "renting" her my Lanz nightgown. We were both concerned about how we appeared to the other girls. We had both gone to public school, and boarding school was such a change—all these preppies. Because I went away first, I was able to let her know that if we wore our public school clothes to prep school, we would stand out horribly.

When she got married, I felt that it should have been me. I was the older sister, and that's how it was supposed to be. I was traumatized because she was leaving the family. She was only 25. I remember her telling me that Bob, her future husband, was the most important relationship

in her life. Suddenly, she was putting someone else in front of the family. She went off and became a wife, and it became more important to her than being a sister.

Professionally, Heidi has it together. She loves what she does, working as a psychologist in a clinic with homeless teenagers. Heidi says that clinical psychologists believe in maintaining their own mental health by not overworking, whereas I don't think architects are as sane.

Whatever Heidi wants and likes to do, she does and does well. She's headstrong. Sometimes she's a really horrible listener and sometimes she's great. Heidi is a lot more articulate than I am. She can be very loose and free. She loves to cook. She loves to make things, and I envy her loose, creative style. As sisters, we don't have to put on any kind of face for each other. Sometimes, I'm much worse with my sister because she *has* to be my sister. I find a lot of security in that.

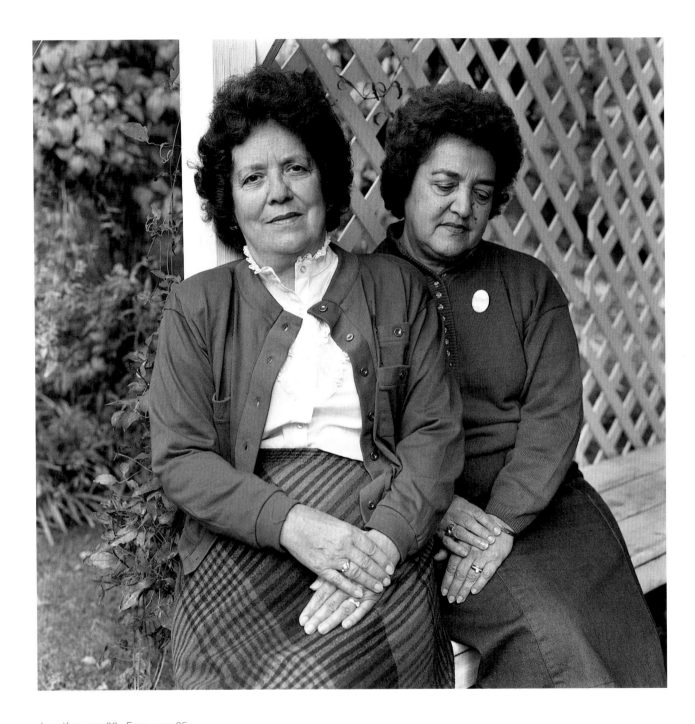

Jennifer, age 63 Fran, age 65

fran
jennifer

Fran, age 76. Jennifer is two years younger than I am. Her real name was Elvira, a family name. She *hated* it. When we were younger, we used to call her Kika. She liked that name, but it didn't work for her professionally, so she legally changed her name to Jennifer. My real name is Francesca.

My mother was born and educated in Italy. Her mother, a midwife, passed away when my mother was 11, and my mother was raised by her father and her sister. Her sister, who was eighteen years older, was also a doctor. My mother always said that her mother took care of the poor, and her sister took care of the wealthy. My mother was one of seven children, four of whom had passed away. My mother came here with her father for a visit when she was 15. She had just graduated from high school and was planning to start college in the fall in Italy. She had come to see her eldest brother, whom she had never met. While my mother was here, her sister passed away. It was the flu of 1918. So they didn't go back. They stayed here. My mother met and married my father when she was 16 and he was 30. He was from Italy, too, and came from a nice family.

My mother's goal in life was to educate her family. She was most successful in her endeavors. She believed that not only boys should be educated, but girls, too, because if you educate a woman, you educate a family. Jennifer went to Westfield State and I went—on scholarship—to Smith. Jennifer and I both ended up teaching, and between us, we have seventy years of teaching. My sister Argie, who has since passed away, also taught. I started teaching junior and senior high and switched to the elementary level. There I started in kindergarten, then went to fourth grade and ended up in second grade. We all really loved the kids.

When this picture was taken, we had both just retired. Even though we both loved teaching, it was this wonderful feeling of freedom to know that we could finally do whatever we wanted. Our children were all grown and out of college, and Jennifer and I were planning a twenty-one-day trip to Egypt and Turkey. We had booked the tickets and had had most of the shots. We met on the corner every day and went for our walk, trying to get ourselves ready for the trip. We were really excited about it. There was this joy of thinking that we actually would go and share this experience that we had talked about for so many years. Then she started to get really tired on our walks. One day we'd gone just a short distance, and she said, "I just can't go on anymore. I don't know why I'm so tired." She found out she needed a pacemaker. After they put it in, it became infected, and we had to cancel the trip. It was our big retirement trip for just the two of us as sisters. We never were able to take that trip together.

Jennifer moved to California shortly after. She didn't want to go, but she wanted to be near her three sons. I said, "You know, it's awfully hard to regret the things you didn't do, so why don't you go and stay for a while. Then you can come back." In the beginning, it was to be a three-year stay. She said she wanted to come back and be with me and my sister Betty, but she doesn't say that anymore. Circumstances changed for her, so she stayed on. At first, I missed her terribly. I missed our walks and going to the theater and the opera. Eventually, I extended my group of friends because I had to, but she was really my closest pal.

I still feel close to her, but it's just not the same, because she's not here, and I can't see her as often. She comes just once a year now and stays a month—two weeks with me and two weeks with Betty. She's changed somewhat. She's more of a California person now. But she's still my sister.

There was this joy of thinking that we actually would go and share this experience that we had talked about for so many years.

I still feel close to her, but it's just not the same, because she's not here, and I can't see her as often.

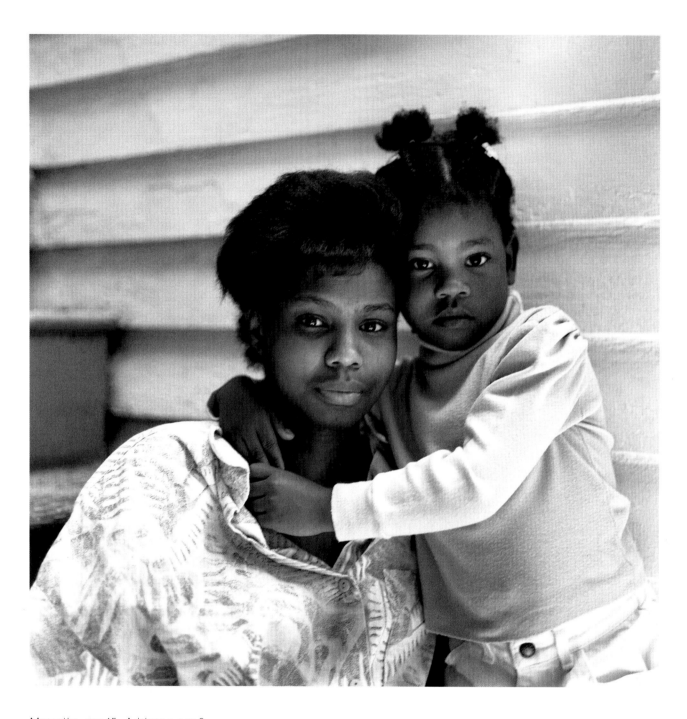

Mareatha, age 15 Adrienne, age 3

mareatha
adrienne

Mareatha, age 30. I had been the only child for twelve years, and then suddenly I had a sister and I had mixed feelings about it. On one hand, she'd go to sleep on my chest—something she wouldn't do for anyone else. But she was also intruding on my life. She was a spirited kid and I thought of her as a pest. I didn't fully accept her as a given until I was 19 and married. I still get jealous about how easygoing my parents are with her. And she gets jealous of my mom's attention to my kids.

Adrienne has always stood up for what she believes is right. In high school she took on the school administration over a controversial issue. She was ridiculed and put down, but she stood firm because she believed she was right. It turned out that she *was* right, but no one ever acknowledged that. Not everyone appreciates her outspoken style. To me, her determination is a positive. I don't think I do that as well or as often as I should in today's world. I want my children to know that quality in her.

Our perspectives are so different that we fight about everything. I'm 30 and married, with four children. She's 17 and has always lived in Amherst. My views are more conservative and hers more radical. She tends to think she knows everything. At times, I have to stop myself from correcting her views.

Adrienne is the generational midpoint between me and my children. Sometimes she'll be extremely mature—more like a peer—but then she'll lose control, and I'll think that she and my 7-year-old have a lot in common.

As we get older, we're more accepting of our differences. We say our piece and go on. We might not talk for a few days, but I respect the woman she's turning into. My mom had breast cancer recently and it drew us together. We realized our differences didn't matter in any profound sense. She's always going to be my sister and be part of my life. When she's not driving me insane, I actually really love her.

Adrienne, age 17. My parents were told Mareatha would be their last child so I was a pleasant surprise—twelve years later. We each essentially grew up as only children, without many experiences in common, and so we're very different.

As a kid I worshiped Mareatha blindly. She was nurturing and patient where I was loud and energetic. I was 7 when she married and in all the wedding pictures I'm crying. I wanted Mareatha to turn at the altar and say, "I can't, I have to take care of my sister." I hated her for abandoning me and afterwards, I saw her as very separate from me—not the person who had been my second mother.

I was 10 when Mareatha had the first of her four children. Her second child is autistic and for a while Mareatha seemed lost and angry at God. I wanted to be more supportive towards her, more like an older sister. Since then, I've come to appreciate what a committed mother she is—all the things that she does for her children every day. I came to see her as more of a regular person and that helped us restore our lost relationship.

Even though she is sometimes nosy, Mareatha balances me out. If we were one person, we'd be a perfect person. People describe me as fiery, loud, and passionate. I am outspoken and extra liberal and my sister is more conservative. Although our political differences can strain us, I never worry that they might cause serious harm. She tries to find our common ground.

When my mom had breast cancer, my sister was the one I went to. She stuck up for me and gave me room to feel whatever I needed. We protected each other. That experience brought us closer than any other.

It's starting to feel okay that there are so many differences between us. She opens my eyes to new ways of thinking. Now that we're more like peers, we're having more fun. I think of her daughters as my little siblings and I love watching them grow. I wonder if Mareatha feels the same way about me.

Sometimes she'll be extremely mature— more like a peer—but then she'll lose control, and I'll think that she and my 7-year-old have a lot in common.

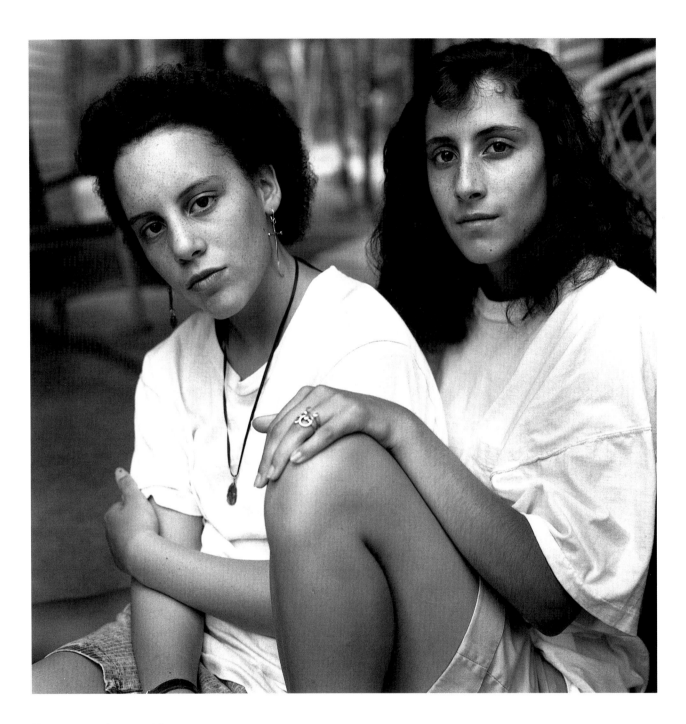

Nora, age 13 Jara, age 15

leila
sierra

Leila, age 15. This picture was taken a week after my dad died. I was 5 and too young to really understand. I knew he was sick, and I remember all the doctors, but I was thinking he'd be okay. He wasn't. Two years after he died, we moved to New York so we could be with my mom's family. We live next door to my grandma, and my aunt, uncle, and cousins live down the road. Sierra lives in Brooklyn now.

I always wanted to be like my older sister. I wanted to do gymnastics because Sierra did it. My hair is really curly, and hers was perfect—long and straight. Sierra is unique, funny, outgoing, and sincere. You can talk to her. She's not like one of those typical high school girls. She went to her prom for an hour without a date. She's dyed her hair different colors. She got "most artistic" for the yearbook . . . she's just different. She's my cool older sister.

I used to be really shy with my friends, but I was never shy around Sierra because she was my sister. I've known her my whole life, and there was nothing to be shy about. We always seemed to get along. I have friends who always fight with their sisters, but I never do. I always wished we were closer in age, but I got a little more attention because I was younger.

When Sierra was in high school, I didn't hang out with her that much. She had a room down in the basement, and she was too cool to hang out with my brother and me. But since she's gone to college, we've become closer. She's realized that it's cool to have a little sister. She can't raise me, but she can help me get through high school and make sure I don't mess up. She always says, "Oh, Leila, you don't need to be part of a group and be a follower. Be yourself and express yourself in your own way." I'm a freshman now, and it's kind of hard because when Sierra was my age, she was one of those girls that you wanted to be.

I still look up to her, but not as much as I used to. When Sierra was in high school, she wasn't bad, but she did some bad stuff. But then again, she was also good.

She was a member of the National Honor Society. I'm smart and have all the friends, just minus the bad stuff. I guess that's how I differentiate myself from her.

Now that we're older, we talk more. Sometimes I'll visit her down in the city. She works at a boutique in Soho, DJ's, and studies sociology. She's very sophisticated. I like fashion and designing things. I want to go to New York City, too, but maybe that's because of Sierra. It's pretty big. I don't know if I could live there.

I say that it's annoying to live with my whole family, but it's actually kind of fun. My mom and my aunt get along really well. My whole family is always together, swimming or barbecuing. Right now, I don't feel as tight-knit with my sister as my mother is with hers, but I feel like when we're older, we'll be like that.

Sierra, age 21. I always think about the part of my life when my dad was alive as if it were a book I read once. It's a story about a girl who had a brother and a sister and a mom and dad. It was good and perfect. Then my dad died, and my real life started. I was 10. This photo was taken a week later. Leila and Robert were 5. You can totally see my dad's death in the picture of Leila and me. I mean, she's so young and little. You expect her to be happy.

I feel like it's my responsibility to remember my dad for them, but I don't recall everything, and the order of events is off. He was sick with lymphatic cancer for four years—from the time Robert and Leila were born until he died. That's all they remember. I have memories of him when he was not sick and of how different my mom was when he was around. I was older when it happened, so my experience was really different than theirs.

I knew he was going to die the night before he actually did. I sat out on the porch with my mom. I was upset. She was upset. But we were kind of relieved, too. He wasn't himself. The next morning I woke up to hear my mom crying. It was like when you're a little kid waking up Christmas morning and you're so excited, but you're

I feel like it's my responsibility to remember my dad for them.

When Sierra was my age, she was one of those girls that you wanted to be.

nervous, too, so you don't get out of bed. I was pretending to be asleep, but I was wide awake, my heart racing. I opened the door and gave a fake yawn, like it was any other day. But I knew what was going on. Everything after that gets blurry.

It must have been weird for Leila and Robert to be so young and have to go to the hospital all the time. I hated it. Children are supposed to get taken care of, but I was taking care of my dad—not solely, of course, everybody was . . . my mother the most. But whether someone said I had to or not, I felt the necessity of helping.

I think my father's death pushed us apart as siblings. Suddenly, I had a lot more responsibility, taking care of them, and I resented my mother for that. My mom was like, "I'm a single mother now, and you have to help." I didn't want to be bothered with them. Now, I have a hard time because I feel like I should have been there for them more. I should have been more of an older sister.

I was 12 when we left and moved into my great-grandma's house. I was furious. My mom redid a room in the basement for me in an attempt to appease me. The first couple of years, I was pissed at my mom and spent most of my life in my room. They all lived upstairs. We never had a bad fight or a big falling out. I was just too wrapped up in myself. Now, Leila and I get along as if we've spent the past ten years together. And we really haven't.

Leila is shy, maybe more so with me than with her friends. But recently, she's been joking around with me. I'm not shy at all. She's a typical teenager, stylish and trendy, but smarter than most. She has some good friends and doesn't seem to be caught up in the popularity drama. When I was her age, I stuck out. I was into raves and wore big clothes like a boy. I had short hair and a pierced

*I should have been
there for them more.
I should have been
more of an older sister.*

tongue. I would do anything nuts, just to make people crazy. I don't worry about Leila making bad decisions, where I might have. I always did well in high school, but Leila tries harder than I do. And she's totally into sports.

As Leila got older, I could talk to her more. I missed having a sister. Up until then, Leila was kind of peripheral. Then I actually started to care about what she was doing. I had always assumed she was fine and I was uninterested in the details. Now I want to know her.

We're not quite peers, but we're moving in that direction. If I'm having a fight with my boyfriend, I don't usually call her. I don't want her to feel like she has to take care of me. On the other hand, I want to be there for her because I'm her older sister. But between work, school, and my social life, it's hard for Leila to get hold of me, much less close to me. I'm sure she wishes that I'd pay more attention to her.

Another thing that keeps us sort of separate is my mystique. I have this reputation as the cool, rebellious older sister. Leila and Robert will say things like, "Well, we could never be as bad as you were." I really wasn't that bad. I can't really live up to their fantasies about my life, but I can show them that, as a woman, you can be smart, have a job, and do cool things. They've seen me get in trouble and get myself out of it. They know I'm crafty.

One of the reasons that I've tried harder to be closer with Leila is because I see my mom and her sister struggling to get along. I get the family politics, and I see them going back and forth about issues like taking care of their mom, who's being responsible for their kids, etc. There are things between the two of them that have nothing to do with being right or wrong. I want to make sure I stay close to Leila.

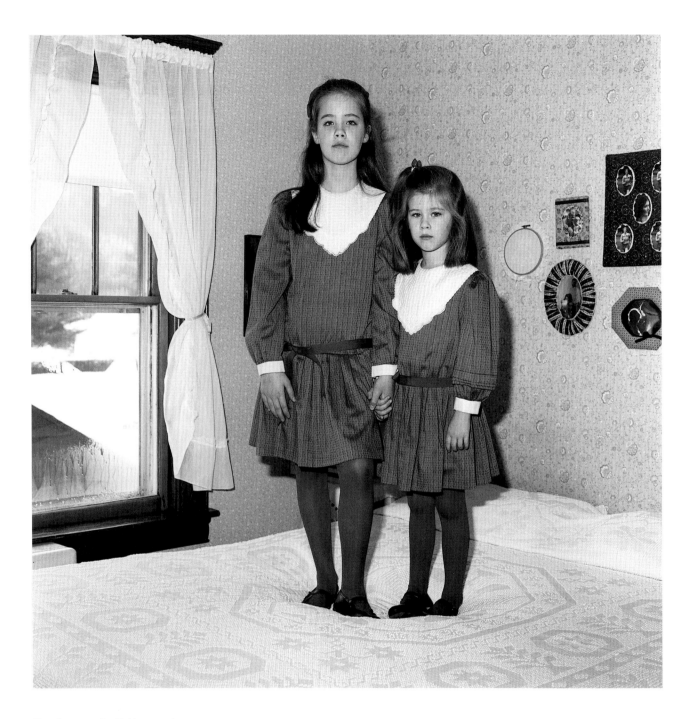

Carolyn, age 8 Katie, age 4

carolyn katie

Carolyn, age 19. Our dad has always been a pastor, and our family life is rooted in Christian values. Because Katie and I were both home-schooled until high school, we played together all the time. Somehow amid dress-up clothes, Barbies, and playing house, we became friends.

I was a bossy child, and I would order Katie around. At one point, I'd whistle for her and she'd come running. I didn't do it in a mean way; I thought it was just my right as the big sister to have power over her. My parents, of course, tried to make me see how ridiculous it was for her to serve me, but for Katie it was a game. And of course, we'd clash from time to time—usually over whose turn it was to be the prince.

Throughout my high school career, Katie watched me like a hawk. She noticed everything—how I responded if this boy liked me or that friend was mad at me. Now I feel an enormous sense of accountability. As she has developed her own standards, I can see the impact my life and relationship with God are making on her. I am so thankful that we can talk about real life issues, spiritual questions and struggles. She listens to me and knows she'll be okay because big sister has already tested the waters. Although sometimes it's intimidating, I love the responsibility of being the leader. I love to feel needed.

Recently, she's become more daring in expressing her differing opinions. She is quite blunt with me, but I like that. It keeps me pragmatic. Katie tends to push the limits more than I do. The clothes she wears or the things she wants to do are often issues, as she wants more freedom than my parents are comfortable with.

Katie has grown up so much. She discarded her braces, mastered makeup, and matured by leaps and bounds. Though she rarely says it out loud, I sense her huge respect for me. Her respect and admiration demand my best—in loving God, loving her, and loving other people. While she doesn't want to become me, there are lots of things about me that she wants to emulate, from my value system to my diffuser gel. I'm glad to have a sister, but I'm thrilled to have a friend.

Katie, age 15. Carolyn is a great older sister. When we were growing up, Carolyn was like my second mother. She read to me, readily shared toys—and she was very bossy. I was stubborn, too, so we often conflicted. We were home-schooled during the day and shared bunk beds and private communication codes at night. If she wasn't there, it didn't feel right.

When she was turning 13 and pulling away, I still wanted to be a little girl. We fought more. She even entered regular high school. She was off doing strange teenager things, and I wasn't ready for that. But I learned from her mistakes. At home, she and I have a whole manner of speaking freely that can make it difficult for us socially in other situations. She is often more honest than people want, and it didn't go over very well in high school. I'm definitely quieter than she is. But that same directness that so irritated her classmates in high school attracted people to her in college.

When she left for college, we evolved from being sisters with sisterly conflicts to being good friends. We took a trip to California together last summer. And when she's home for Christmas, we'll go out, just the two of us. We really have fun.

Faith plays a huge role in our relationship. Her moral positions on things like dating really impact me. I don't agree with everything she says, but I certainly respect it. It's as though my personality sort of grew as a balance to hers, and we're developing our moral thinking together. She went first and discovered herself with her faith, and she shares it with me now. We're together so much that I can't even imagine what I'd be like if I didn't have an older sister. She's my most intimate confidante, my guide. She's still one step ahead of me.

She was off doing strange teenager things, and I wasn't ready for that.

She is quite blunt with me, but I like that. It keeps me pragmatic.

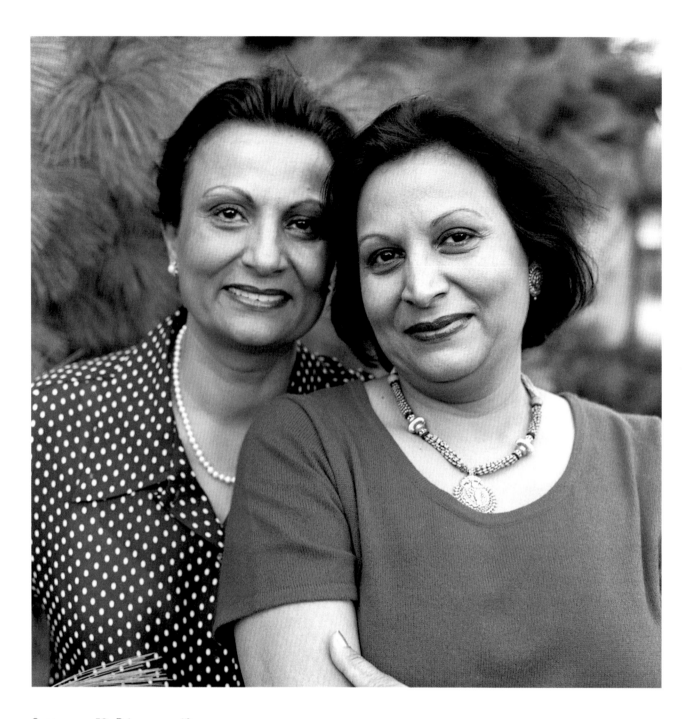

Suman, age 53 Priyam, age 48

suman
priyam

Suman, age 53. My sisters and I grew up in a close-knit family in New Delhi, India. I was the middle of five children. As a young woman, I had plans. Any time my parents talked about my wedding, I'd say that I wouldn't marry until I had my master's or Ph.D. from the United States. Seeing how determined I was, my father said, "I can't afford to send you there alone. The only way is for us to find you a boy who is already studying in the U.S. who plans to return to India." And so, my marriage was arranged. My husband and I corresponded through letters for several months. Nothing was fixed until we actually met.

My husband sent his brother, Naresh, to check me out, to find out my likes and dislikes and then report back. But Naresh kept hanging around our home even after I had moved to the States with my husband. He'd make up different reasons to be there, but in truth, he was interested in my younger sister, Priyam. When I found out that they wanted to date, I was not in favor of it. I worried about what would happen to us if one sister was happy and the other was not. Thank God, we're both happy.

Because my sister is also a sister-in-law, we can talk about anything. She's a peacemaker. She'll keep a lot to herself, whereas I'll say immediately if something is bothering me. I'm protective of her. She tells me I'm too serious.

During Raksha Bandhan, we pray to God to give our brothers a long and healthy life, and in return, the brother pledges to take care of the sisters. The brother usually gives something to the sisters—a gift. Last year, our brother gave the three of us $100 each. We play cards for money, and eventually we noticed that my brother had won most of his money back. So my sister Priyam announced another Raksha Bandhan. We all burst out laughing.

We lost our parents and our mother-in-law two years back. Now, we just have each other. We sisters decided that we would lend our support to each other so that we could all shine and do good. We practice compromise to stay together. Our children see us celebrate, laugh, and cry together. We join our families. Together you can do so much and with so much joy.

Priyam, age 48. In my family there were five. Recently, my brother passed away, so now we are four. Sushma, the oldest, is the funny one. She's relaxed, motherly, and home oriented. Two years younger, Suman is serious, independent, and aggressive. I'm a mixture. Like Sushma, I seek out harmony and fun. But like Suman, I enjoy working hard. Suman and I are sisters, sisters-in-law, *and friends*.

As children, we had a peaceful, loving relationship. As the baby girl, I was pampered by everyone—my parents, my siblings, our servants. Suman took care of me, too—comforting me when I was scared, playing with me. When I was in high school, Suman was in Bombay studying. Suman soon married and moved to the States. Sometimes her in-laws would visit us in New Delhi. I'd look after one of their sons, Naresh. He formed a liking for me. Eventually, Suman asked Naresh if he had found a girl he wanted to marry. He wrote back, "Yes, and she's always around you."

Suman and my parents were skeptical about two sisters marrying into the same family. But my mother-in-law was in favor of the match. I felt good about it, too. We knew the family, the boy. So I said yes, and we started writing. Ten months later, we married and moved to the States. I've been really happy, thank God.

Suman and I spend a great deal of time together—at family functions, at parties, shopping, or on vacation. If I have family concerns, I talk to her. We know and love each other's children. Our kids say, "If Mom knows something, then Auntie does, too." Sometimes we don't agree, but we can't be separated for too long. We start missing each other. When our parents died, we realized we were it, so now we make an effort to be together and united. It's such a joy to share so much with each other.

Suman and I are sisters, sisters-in-law, and friends.

We sisters decided that we would lend our support to each other so that we could all shine and do good.

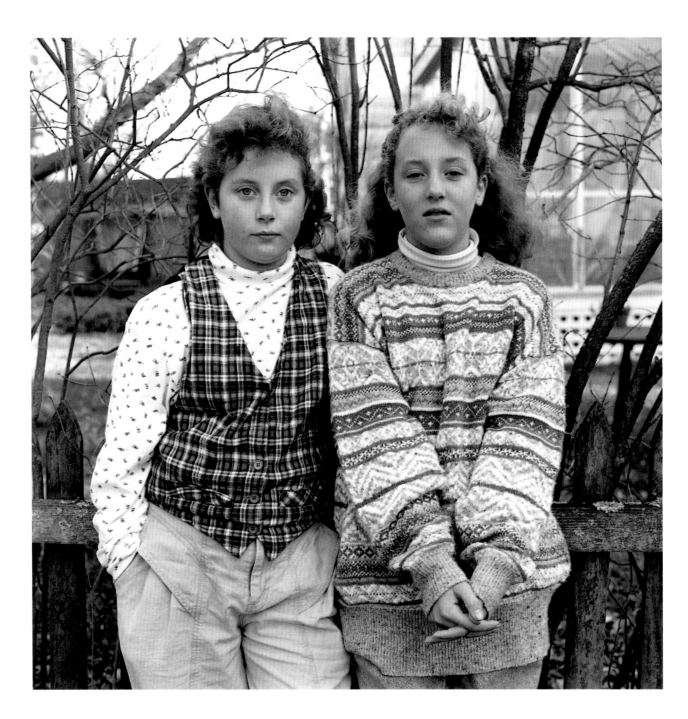

Sarah, age 10 Kate, age 10

kate
sarah

Kate, age 23. I had always assumed that since my parents were unaware they were expecting twins and I was delivered second, I was the "surprise." I could give you a thousand euphemisms for *unwanted.* Whether it was a lack of self-esteem or a rotten relationship with my sister, I never considered my arrival a blessing. My parents, of course, would tell you otherwise. My sister, in our younger years, would say simply, "I came out first. Frannie (my nickname) was a surprise." There's that word again.

At the age of 20, I found myself one year into a relationship with the most wonderful man. Adam had rescued me from certain death or paralysis one day when I was rock climbing with a friend. We were climbing without ropes, and it was my first time on actual rock. This is one of several miraculous events that brought and kept us together.

On May 30, 2000, I found out that I was pregnant. I was traveling with friends in Europe. I was on my way home less than forty-eight hours later and presented Adam with an "I love my Daddy" bib. We were both frightened and very excited. It was never a question that we would begin a family together. We exchanged vows on August 12, 2000.

Because of my age and perceived lack of life experience, not everyone welcomed the news of my pregnancy and anticipated nuptials. I was extremely unsure how my sister would react. My own best friend had groaned with sympathy. I was excited and wanted someone to share this with. My sister was on Nantucket for the summer, so I took the leap of faith and called her. I have never heard more welcome shrieks of delight as I did on that night from my sister. She was screaming to her boyfriend, Pete, "I'm going to be an aunt! Frannie's pregnant!"

My relationship with my sister had always been rocky. We had chased each other with sharp utensils, attacked each other's egos, and always tried so hard to separate from each other. As soon as we were forced apart by the geography of our respective schools, our friendship began to blossom. We discovered that we actually needed each other. Years ago this idea would have instigated retching noises. How could this person, forced upon me from birth, ever serve any purpose but to torment my every moment of existence? I couldn't have been more wrong.

With the wedding and subsequent holidays approaching, the excitement was building. Sarah was the only one who called me regularly. In my eighteenth week of pregnancy, my husband and I learned we were expecting a little girl. Sarah was away in Africa and I was adamant that the sex of the baby remain a secret until she returned home. People can dismiss the twin connection or telepathy, but I would beg them to reconsider. My sister, in a sudden panic and homesick, had made a phone call home to my mother. She was in tears and she needed to know the sex of the baby. My mother was perplexed, but conceded and told her about our little girl. In this way, she and Pete were able to begin the celebration of the life of Elli Jane Smith, and not a moment too soon.

When she was traveling home from Africa, she continued to feel a sense of deep urgency to see me. I don't think that feeling of unease left her, even when she landed safely on American soil. My entire pregnancy I had a similar feeling. In my dreams about my daughter, she would come through my belly and everyone would be able to hold her but me. Anytime she was in my arms, I would drop her. I think my sister was able to detect my angst somehow, although I had never alluded to it in any conversation or correspondence.

On January 9, I went into labor. On January 12, I gave birth via an emergency cesarean to a beautiful baby girl, who was also critically ill. Around the time when Sarah and I had experienced our most heightened anxiety, Elli had become ill with a virus, similar to a common cold, that I had passed on to her in the womb. Apparently, one in a hundred women will catch this virus during pregnancy and of those, one in a hundred will pass the

How could this person, forced upon me from birth, ever serve any purpose but to torment my every moment of existence?

virus on to her unborn child. Due to extensive brain damage and potential liver failure, we faced the decision of taking Elli off of life support. On January 13, Adam and I said goodbye to our little girl.

When I had gone into labor, Sarah came with balloons. When we bid farewell to Elli, Sarah was still there with food, laughter when needed, friendship, and hugs. I had forbidden tears—they were not to be shed in front of me. Adam and I were strong for each other, and our relationship solidified. However, I still needed Sarah.

For the remainder of her semester break, Sarah would come to our apartment every day so Adam could go for a run or a hike. No one liked the thought of me being alone, especially Adam. When Sarah returned to school, we would spend every Friday together, walk my dogs, go out to eat, whatever made me feel okay and safe.

My sister, my nemesis, my cheerleader. She was a crucial ingredient in a remedy that started the healing process. She cried joyful tears when I told her I was pregnant again. Oddly enough, neither of us had any anxiety during my second pregnancy, not even when Sarah planned to return to Africa just weeks after my due date. In all my dreams, I birthed my baby, held my baby, and even fed my child from my breast. With this confidence, my husband and I delivered a very healthy and magnificent baby boy, Noah Addison Smith. My sister, formerly repulsed by any bodily fluid, had wanted to be there. My husband and I chose to be alone to complete this journey. Sarah was there almost immediately after Noah's birth and was interested in all the details. She visited several times and came to the send-off from the hospital to our home.

During my maternity leave, Sarah and I spent time with each other on a regular basis, once Adam returned to work. She dotes on Noah and they have developed a loving relationship. Sarah has continued to be my friend, my sounding board, and most importantly, my sister. We have our disputes, but we move quickly past them.

I can't explain why it was so important for me to separate myself from Sarah. At certain points in adolescence, I was certain she was evil. As it turns out, however, we were both fighting the same demons. I wish I had realized that back then. I really could have used her support. Now I don't know what I'd do without her. She's truly my best friend.

Sarah, age 23. Growing up, I never thought that I would love my sister. We fought with such a ferocity and cruelty that it made my parents crazy with frustration. I desperately wanted not to be a twin, not to be part of the matching set, and to be able to celebrate my birthdays and other milestones by myself. I am not sure why we hated each other so much, but for a good ten years I resented her to the point of not being able to even see her as a person, rather than an appendage.

Fortunately, in the past few years, all this has changed, much to the relief of friends and family members alike. As soon as I got to Mount Holyoke, it seemed that Kate and I were forming a tentative friendship. We both scratched our heads about this and proceeded cautiously, but at the same time I think that we were happy that our relationship had finally started to change. We did things together and we did not fight. Amazing! I talked to her about my life and she listened and gave me advice instead of ridicule, and I tried to do the same for her. It seemed bizarre, but we were actually starting to like each other. That is not to say one day we woke up and we were best friends. We still would have some epic squabbles (no longer brawls), but we would get over them and move on and continue trying to get to know each other. It has been a long reconciliation, but now I can't imagine my life without my sister.

As we approach 24 this year, Frannie C. (my childhood nickname/taunt for her that she hated but has settled into not by choice, but by my persistence at calling her this) is easily one of my best friends. When I come home now, she is the first person that I want to see and the first person that I want to call. We have fun together and we are finally comfortable with each other, which is nothing less than fantastic.

Now that Kate is the mother of a beautiful, amazing, adorable, brilliant baby boy named Noah, our relationship has gotten even better. Kate has a new calm about her, and you can see how she basks in the joy of her ridiculously awesome boy. She is an incredible mother, and I know that she will be a fabulous aunt to my as yet unplanned children. I think I will insist that they call her Auntie Kaka, which I am sure she will hate but grow into, just like she did with Frannie C.

What else can I say about my sister? I think that she rocks and I feel lucky to have her in my life. I love her!

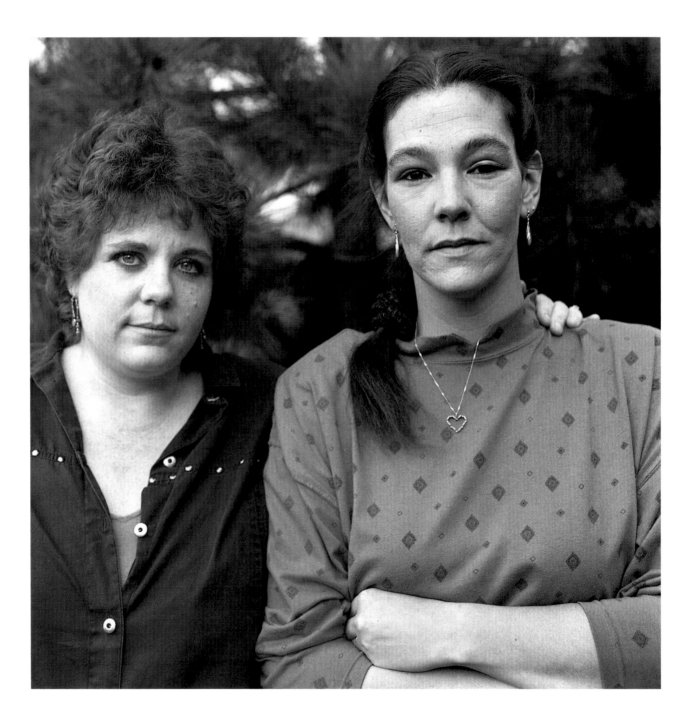

Kathleen, age 34 Wendy, age 32

My sisters are witnesses to my history. . . .
They define the core of where I am and who I am. **Debra**

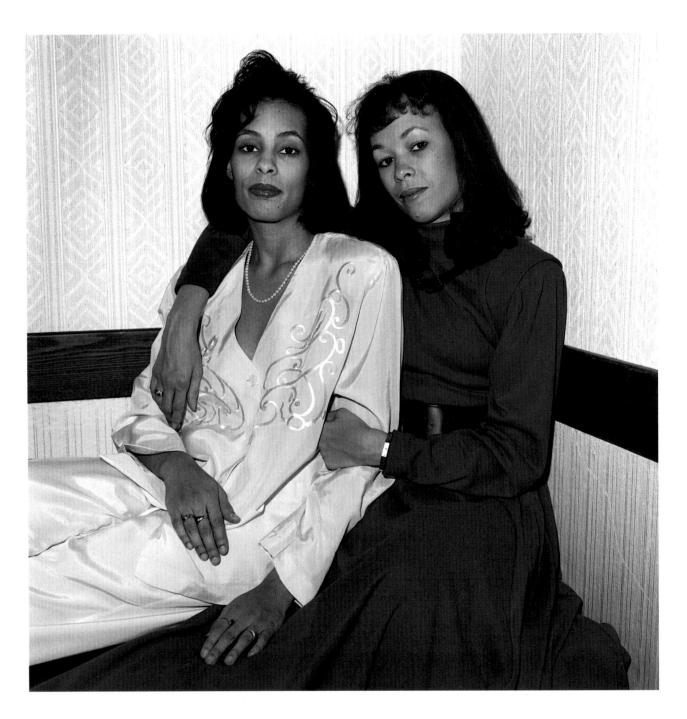

Veronica, age 26 Jackie, age 33

jackie
veronica

Jackie, age 45. We are four sisters. Josie is 48, and she was raised in North Carolina. She is my father's child, but not my mother's. My mother had Deidre, who is 46, me, and Veronica, who is 39. At the time of this photograph, Veronica lived next door, and her life seemed free and easy. I was doing old-married-woman things—the house, the baby, the job. Compared to her, I felt tied down.

When Veronica was born, I was both jealous and possessive of her. When I wasn't carrying her around on my hip, I was teasing her mercilessly. As a teenager, I was cast as the smart one, and Deidre was the popular one. My parents had her drag me everywhere to get me out of the house and to keep her out of trouble. As the oldest, she was held accountable when things went wrong. Veronica's job was (and is) to be adored and to demand. She was a real nuisance.

Growing up, I didn't really think of Josie as our sister. She lived far away, but my mother consistently encouraged us to be connected. Mom was always fussing at my father to make sure Josie had this or that. And it paid off. When we got to know and love each other as adults, we'd refer to Josie as our sister. When we had children of our own, we made the effort to visit and have the children get to know each other. You have to know who your people are, who your family is.

When Deidre's son died of sudden infant death syndrome, she was distraught. We wrapped her up, held on, and took care of her until she could pull herself through. That's when Josie really opened up and took us in like we were all sisters. Josie had four kids, and she could really relate to my sister on a level that we couldn't.

Four years ago, our father died. While it brought the three of us closer, Josie seems to be farther apart now. My father was a strong tie between us. If we don't make the effort, our relationship with her will drift slowly away, but everyone is so busy that nobody is really trying. It's much easier for the three of us because we are all here in the Springfield area and we have our mom around.

Veronica, age 39. Deidre, Jackie, and I grew up together. Josie, our half-sister, is from my father's first marriage. My mother took care to include Josie as a sister. We visited. Josie had whatever we had—money for college and a house, etc. My mother knew that family is family. She and Aunt Soodie (Josie's mom) love each other . . . even vacation together. I'm sure my mother has a sense of peace, knowing that she did the right thing by Josie, and Josie is very good to her.

Deidre had a son on Christmas Day in 1984. A few weeks later, the baby passed away from sudden infant death syndrome. Deidre was devastated. We just stayed all around her, just held on. When my son was born, Deidre clung to him like glue. I think she was worried that his life would slip away, so she was literally trying to hold on to it. I didn't mind. I understood—it was part of her grieving. Now Deidre is a terrific foster mom.

I also have an adopted daughter. She was born prematurely and struggled with serious health issues. I was her primary nurse. I first worked with her biological mom and then her foster mom. I was also her home nurse. Eventually, Patrice became eligible for adoption. My family, especially my sisters, were all encouraging me to adopt her. "Just get her! We'll help you!" And they did. They embraced her.

It's not that difficult for me to be a single mom, because my sisters give me all the help I need. Jackie helps me talk to my now-teenage daughter, and I try to emulate Jackie's quiet reason. Deidre always "does" for us. A talented thrift store shopper, she keeps us all looking so sharp. She's always bringing things or driving my son around. I'm inspired by her desire to give.

When my father was dying, we grew tighter as sisters—all that time together. I don't share every last thing with my sisters, but I feel a profound sense of connection to them. I know they're going to be my sisters no matter what. I feel so blessed to have them. They are just in me.

When I wasn't carrying her around on my hip, I was teasing her mercilessly.

It's not that difficult for me to be a single mom, because my sisters give me all the help I need.

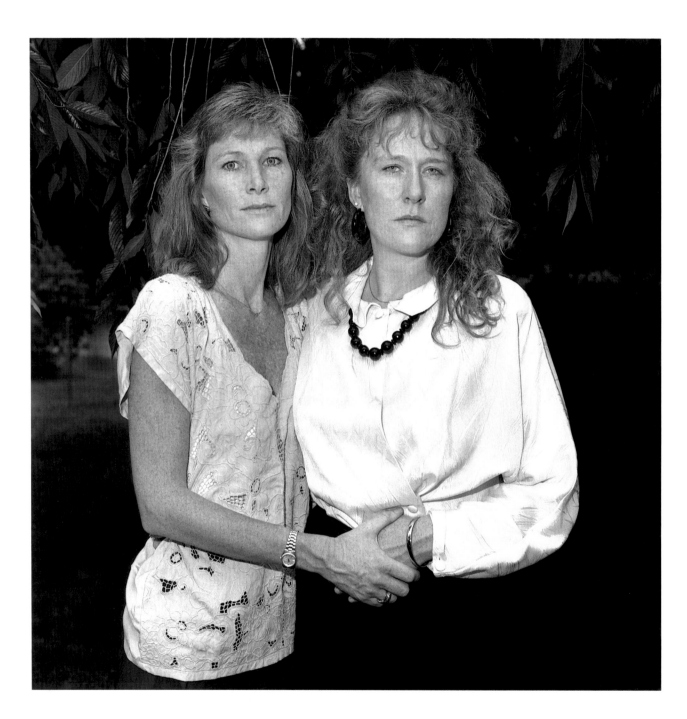

Joanne, age 35 Kate, age 31

kate joanne

Kate, age 41. Joanne and I are half-sisters. She's four years older than I am. Her mother was about to enter a convent when she met our father. Her mother married at 19, and she died in childbirth at 20 on a naval base in Guam. Our father married my mother when Joanne was 11 months old. He and my mother had Tom, me, Mary, and Joe.

No one ever sat us down and said, "Joanne's mother is different than your mother, and here's the story." I only knew Joanne had a different mother because her mother's passport was in our house and her picture was inside. I didn't really learn anything about my father's relationship with her until I was 19. My father was sober for just three months—he'd been an alcoholic all my life. I came home one weekend during his sobriety, and he talked to me for five hours straight. He told me the story of his marriage to Joanne's mother and about her death. That's when he started drinking. Joanne never really got any more information than that.

It's so hard to explain what the adults in our lives tried to communicate to each other through us. On the one hand, my father wanted my mother and Joanne to feel like mother and daughter, and yet he didn't allow my mother to adopt her. My parents had a terrible marriage, and this was a way to keep Joanne separate, to keep the memory of his first wife alive. In the town where we grew up, there was this ugly picture painted of Joanne as kind of a tortured soul, which she was. And I had the persona of being the golden child, which I wasn't. I felt guilty because I was my mother's natural daughter. I remember being at a neighborhood party and someone saying to me, "Oh, you're Nancy's *real* daughter." I was my mother's oldest daughter, and I looked like her, and people aligned us. Joanne is tall like the rest of us, but she's much leaner. In the face we look alike. You can tell we're sisters, but her whole physical makeup is different than mine. My mother finally tried to adopt Joanne on her deathbed when Joanne was 23.

Of course, I was wild about Joanne. I wanted to be just like her. She was really, really smart. I remember in fourth grade she won some essay contest: "What America Means to Me." And she was tough. Some kids went to beat up my older brother on the bus, and she kicked their asses. Then comes that time in your life when your older sister starts paying attention to you. And it's *incredible*. She was 20 and I was 16 when we waitressed together at the Pancake Man. We used to go out together after work and drink and have a great time. She liked me and thought I was cool. That was really big.

We were both in Montreal during my first year of college—the year my mother was diagnosed with cancer. We entered the up-and-down world of cancer—they have it, they don't, the treatment's working, it's not. It felt very secure for me to have Joanne with me. If I had a hard time I could always talk to her, or she'd give me five bucks here and there.

Joanne moved back home to care for my mom. I went home one summer, but I didn't go home anytime after that. I hated being around it. I wanted to escape from my family. So here's poor Joanne, 23, dealing with all this. My father's stopped drinking for the moment and wants to talk constantly. My mother's now setting up for parties that no one's ever been invited to. My mother went off the deep end partly because she had brain cancer, and partly because she had been crazy all those years and keeping it together while my father was drinking. She just broke down.

My mother was released from the hospital to our house—no heroic measures taken—and she was terribly sick. I drove down from Montreal and saw her on Friday night. My brother Tom was in from Boston, and Mary and Joe still lived at home. Joanne was working that night and was supposed to come home the next day. Saturday morning, my mother died—right there in the house, with all of us with her . . . except Joanne. The ambulance came for my mother, and I stayed and waited for

It's so hard to explain what the adults in our lives tried to communicate to each other through us.

Joanne for about half an hour. Eventually, I left for the hospital. Joanne arrived about ten minutes later. She came home to an empty house.

My mother died Saturday, and we buried her on Tuesday. On Wednesday, Joanne told us she was going to marry this guy on Saturday, and she did—a week after my mother died. So here are all these crazy Irish people flocking in for a funeral, and they all just hung around for the wedding!

Both of my parents had died by the time I was 21. My mother was sick for four years. She died of brain and bone cancer. We knew she was going to die. My father just dropped dead. The death certificate says my father died of a heart attack. The heart attack was brought on by alcohol and drugs, but there's no record of that. It's hard to know how much was intentional, and the idea of that is *very* controversial in my family.

It wasn't until after my parents died that Joanne started to explore her mother's life. I think she thought it would have insulted my mother. When my grandfather died, we buried him at the Arlington Cemetery, where Joanne's mother was also buried. After the funeral, the five of us worked with this map to find her mother's grave. It took a really long time, but we finally found it. It was the first time she had been there. It was the first time that the facts of Joanne's life were out in the open. She was 29.

At the time of this photograph, Joanne was 35 and I was 31. I was up and coming in the college administration business, and I had just "come out" as gay in the last few years. My sister was a young mother. I don't think I appreciated her then the way I appreciate her now. She can be aloof. When she's having strong feelings, the last thing she wants is for you to be close. And she's strong-minded; she's a decision maker. When my partner and I adopted the kids, Joanne had a lot of opinions about the way we ought to parent. I don't think she really meant to be critical. I think she thought that it was her role as my big sister—to instruct me, to tell me to relax.

One day, Joanne said something about the kids, and I was so mad I was ready to leave. I was getting my stuff together, and she said, "So, are you just going to leave mad like this?" It took every molecule in my whole body just to stand there and talk to her about it. We'd never done anything like that before. Afterwards, she wrote me this beautiful letter, saying that it was such a great thing we had done, that she would never judge me or my partner, that she loved me. Things have changed since then.

Recently, we've been e-mailing back and forth. It's impossible to have a daily relationship with someone who lives in another state. Now, at 41 and 45, we talk about our work and parenting—not these big, intense conversations about our past. The regular stuff somehow makes me feel closer.

I always wanted Joanne's life to be better. She has always seemed so fragile to me. I've always worried about her. Sometimes it feels like I'm the older sister. I think she'd say the same. Sharon Olds wrote a poem about how her older sister stood in front of her, protecting her, while all the bad things happened. My parents were terrible, and Joanne got the brunt of it. She got what I didn't get, and I'm grateful to her for that.

Joanne, age 45. This photograph has always been kind of funny for us. We feel so guilty that Mary isn't in it. Even though she wasn't in the area at the time, it's weird to have done this sisters thing without her.

I'm the stepdaughter. Kate is my half-sister. My parents got married young and lived on a naval base in Guam. My mother never arrived home from there alive. She died when I was 3 weeks old of a blood clot in her head. My father and I lived with her parents in Boston for a while. My father met my stepmother. He was still in the navy, and he was going to be transferred to the West Coast for the next three years, so they had to marry right away or wait three years, and there was "the child to consider." The child, of course, was me. So this marriage, which probably should never have happened, happened.

My father never really got over my natural mother's death, and it made for lots of weird stuff between my father and my stepmother. I never knew my mother, but she was this looming presence at home. Within my father's family, there was a lot of focus on me as kind of this survivor, a golden child. I was the living remains of my father's first marriage. My natural mother's death set me up to be the apex of all these triangles. There was me, my stepmother, and my father. And then there was my stepmother, Kate, and me. I was the first daughter, and yet, Kate was my stepmother's first daughter. It was very complicated.

Mom (I called my stepmother "Mom") wasn't the strongest human being. She leaned towards paranoia. When we were young, my parents would have these knock-down, drag-out fights . . . throwing things across the living room. Mom would announce that she was going to put "her" children in the car and drive them all into the Charles River. Sometimes, she'd say things like "Kathleen is my first child." I don't think she meant that Kate was perfect. Rather, it was her big, angry slap—completely directed at my father.

As an adult, Kathleen has said to me that I was a combination of abused and neglected. If my parents paid attention to me, it was to abuse me. I couldn't make a move and have it be right. It put Kathleen in the position of protector. Once, when I was 10 and Kathleen was 6, we were clearing the table after dinner, and my mother called out to me, "Honey, would you bring that over?" Kathleen whirled around, her face lit up, and she said,

"Mom, you called Joanne 'Honey.'" And then I realized that nobody ever did that. Kathleen was always happy when the people around her are happy. She was the sunshiny child. I'm just not made that way.

We laugh now and say we never talked as kids. You never expressed a desire or a need. You never made waves. On the other hand, we had dance and music lessons. We went to private school. They had no money, so I know my mother ran herself ragged for us.

My mother got breast cancer and had a mastectomy. I was in France, and she told me not to come home. The doctor said six months, but she lived many more years. She spent most of the last year of her life in the hospital. Because I lived in Boston, I saw her every day at the hospital. I felt fortunate that I was able to do that. She had tried to adopt me as a child, but my father never let her do it. She went to do it again when I was an adult, shortly before she died. We thought it was done, but we had only begun the process. I was never fully adopted.

Mary, the youngest sister, was finishing high school, and being at home was really hard on her. My mother's cancer moved into her brain, and she had determined, in her lunacy, that she hated Mary. After my mother died, Mary lived with my father. He was 50 and attractive and he found a girlfriend named Elaine, the name of my natural mother. She was the age my natural mother would have been . . . and the same size. It was very warped. My father died within the year of a heart attack. I was 25. My brother, Tom, was 23. Kate was 21; Mary, 19; and Joe, 14.

After my parents died, I remember feeling free and then feeling guilty because I felt free. Freed from the complexities. Freed from having to play the good little girl, the roles. Free finally to get to know my siblings as people. For example, once, when I was in high school and my parents were still alive, we all went to the cemetery to visit Granny's grave. I can remember my mother saying in an upbeat tone, "Tom, why don't you take us all down to Joanne's mother's grave so we can all say a prayer there." He made such a big stink about it that no one wanted to go near the place. It wasn't until later, when my grandfather died—after my parents were dead—that Kathleen said, "Let's go find Joanne's mother's grave." We could finally go down there as a family and acknowledge this. We all felt it. This was part of all our lives.

We kept the house so that the two youngest, Mary and Joe, could live "normally." What started out great ended in terrible infighting. I had a dream one night that my mother would come back and kill me if I let this family fall apart for a house. Being the oldest, I was always in charge. There was so much chaos in our house that I learned to be super-responsible. I'm not power-hungry, but I am control-hungry. I decided to sell. When you want to talk about something, you call Kathleen. If you want something done, you call Joanne. By the time the house sold, I had married, and I wrenched Joe off to live with us in Washington. He was miserable. I didn't know anything about parenting at the time. Nobody was really taking care of Mary. Everybody was grown up, and yet, not really. Everybody was grieving and surviving.

I love Kate, and she loves me. She's always been more important to me than any friend. She's my closest confidante, although she's as flaky as the day is long. I know my siblings' perception of me has been that Joanne is cold and businesslike. I know that Kate sees far beyond that. We have a personal adult sibling relationship.

And Mary. We need her in the picture. She is significantly younger than I am, and for better or for worse, it kept her out of the fray. Mary clung to Kathleen. I think what formed much of her childhood was that I had all the attention—even though it was bad—and she had none. Kathleen is always in the role of peacemaker. Kathleen can't stand for anybody to be unhappy, whereas I might say that it's good because you might learn from it. There's a lot of unhappiness—a lot of old wounds—that just haven't been dealt with.

I laugh from my lofty perch, because Kathleen struggles daily with motherhood. I wish I could make it easier for her, but you kind of have to watch her struggle. I admire what she's doing now. I think she's a cool human being. We don't have an everyday relationship, but our relationship is warm. You can tell her anything and she'll understand. She's the first one I tell big things to. She's not judgmental. She's just kind of a loving presence. I wish we had more communication.

When mothers die, strange things happen. The structure breaks apart. There's no need for hierarchy. When the crisis is ongoing, you react. You learn to save yourself. I have this chest with portraits of Tom's mother, my natural mother, and my stepmother. My husband and I laugh and call it the altar of the dead mothers. Even my husband thinks it's weird with the three, and I say, "That's what motherhood looks like in my life. I'm not going to have to choose, as I did as a kid. Which one is the real mother? What's your mother's maiden name? Well, which frigging mother?"

Imagine how lonely I'd be if there were something in one of them that said, overtly or covertly, "She's not really us." They may love me or hate me, but I am fully theirs. I belong there. I'm deeply grateful for that. It helps that I was the first. I'm the constant. I've always been there.

After my parents died, I remember feeling free . . . Freed from the complexities. Freed from having to play the good little girl, the roles. Free finally to get to know my siblings as people.

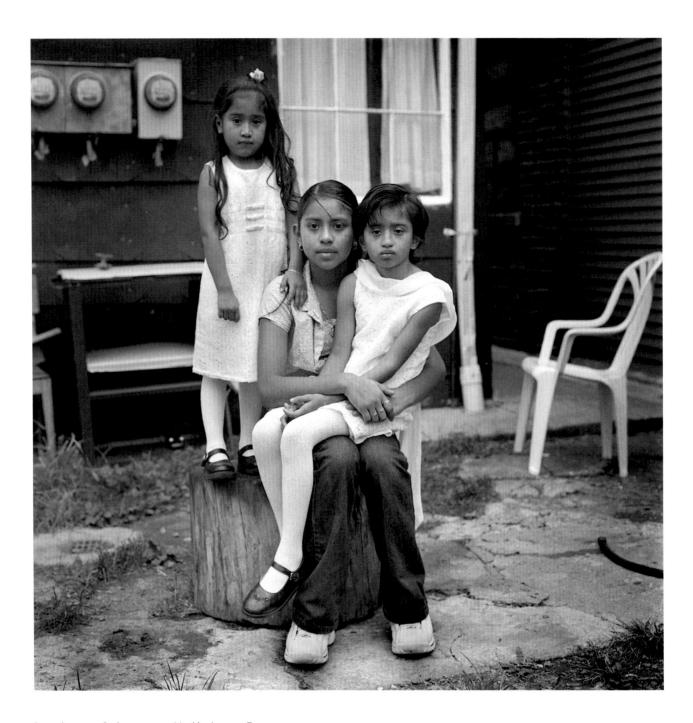

Lourdes, age 3 Laura, age 11 Karla, age 7

laura
lourdes
karla

Laura, age 14. We moved from Mexico City to the United States when I was a year old. I am the oldest. Then there is my sister Karla, who is 10, and my brother, Roberto, who is 8. They were both born in California. Lourdes was born here in Chicago. She's 6.

Karla was sick when she was a baby. I was about 6 years old then, so I don't remember too much about it. I think she had a hole in her heart, and they had to operate on her. Something happened to her brain, and now she's different. She used to go to the same school that we do, but they changed her to a special school. Sometimes I feel sad for her because she wants to play with the little girls on the block, but they don't want to. I think they are afraid of her because she's different. She looks really young, like 6 or 7, but she's not . . . she's 10. I tell the girls to play with her, and they usually do. Lourdes knows that Karla is different, but we don't talk about it. It's just part of our life and that's it.

I like to play with my sisters. We'll color, go outside, go to the park. When Lourdes was 5, we had a baptism party for her. There was a DJ and food and dancing — everybody was around. It was probably the most fun I've ever had with my sisters. It's a little harder with my brother. He and I don't like the same games, and we can't talk about clothes. My sisters see me as working hard. I like math, and I've made it to high school. My goal is to be a private detective.

Sometimes my sisters can be really annoying. Karla will be staring at you and she won't stop, even when you tell her to look somewhere else. And Lourdes still cries a lot. I don't really like sharing a room with them because I don't get a lot of privacy. They don't listen to me when I want them to be quiet. Sometimes I just want to be by myself.

I'm the only person in the family who speaks English. Sometimes they give Karla homework in English, and I have to help her. My dad speaks a little bit of English, and my mom doesn't speak much at all. I have to translate for them all. I have a lot of responsibility in the family, and it can be kind of difficult for me. But overall, I like being the older sister. Our parents let me go out more than the others, and I get a few more privileges. Someday, I would love to go with my sisters and my brother to Six Flags. I've already been there and I know they would love the rides.

I have a lot of responsibility in the family, and it can be kind of difficult for me. But overall, I like being the older sister.

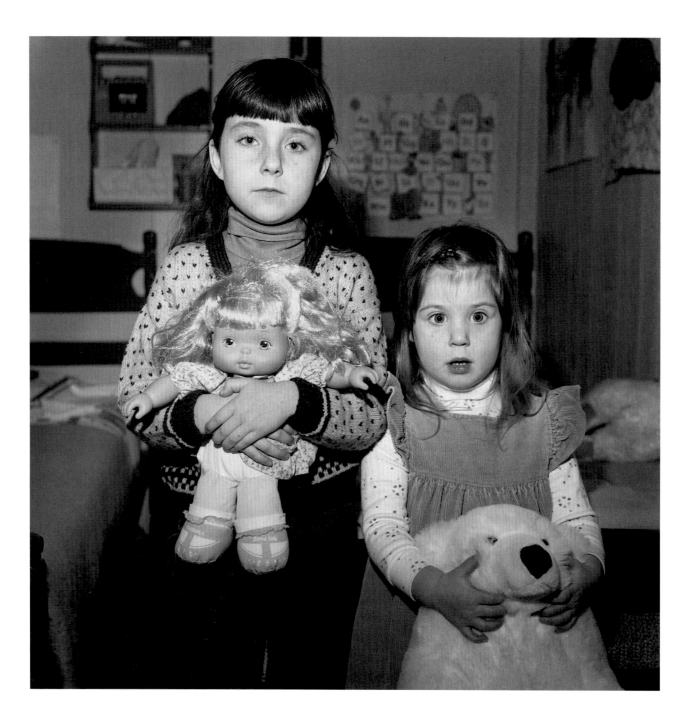

Juliana, age 6 Alice, age 3

juliana alice

Juliana, age 15. When we were kids, there weren't a lot of kids to hang out with, so Alice and I were constant companions. We played this embarrassing pretend game that involved a princess and a poor girl who's lived on the street her whole life—who has never seen a TV or anything. The princess takes her into the house and shows her the TV, and the stereo, and the fridge. It turns out they were long-lost sisters.

For a while, we were at each other's throats. I was in this really bratty stage, and everything ticked me off. I didn't see my dad very much, but my mom and Alice drove me insane. Alice would go around humming endlessly, and it annoyed me deeply. I'd ask her to stop and she'd refuse.

I grew out of that, and now it's pretty nice. I wouldn't want her to know this, but I look out for her sometimes. I feel a little responsible for her. I'll try to cheer her up if she's had a bad day. We hang out together watching TV and listening to music.

There's a lot of competition between us, and it makes Alice mad at me. She just happens to do a lot of the stuff I'm really good at. Take ballet. I've been dancing forever, and now I'm a member of the company. Alice was less rigorous in her training, and then she couldn't dance at all last year because of an injury. And math. . . . She was selected, like I was, to skip seventh-grade math and go straight to algebra. There's no way to put this nicely, but I think it was easier for me, and I'm sure she feels that. She wants to be taller. She's counting the inches.

I'm more careful with her than with others. I don't see my friends after a horrible day at school, like I do her. We don't really go out and do stuff together. But there is something else between us. I guess we've just known each other all our lives.

Alice, age 13. Juliana was my best friend growing up, but she was also the only person I knew really well. I was jealous when she'd go off to school and excited when she got home. When we moved, I made new friends, and we didn't play with each other as much. At home, we started to close the door and say, "Get out!"

Juliana can be really annoying. She'll take all my CDs in her room and won't return them. I have to dig through her messy room to find my stuff. It's also annoying that she gets to go off for five weeks to dance camp, and I'm stuck at home. She'll yell at me because she has to yell and I'm there. And when she's around, she has a lot of criticism to offer. That's her gift: "Here's my critical view on your life."

Sometimes we get along. We'll listen to my latest CD while she's cooking. She and I are both interested in chess. We're both good at math, and she helps me with my homework. We talk some, but mostly we do things together. I ask for her advice sometimes because she's a kid, whereas Mom and Dad are so much older. Her advice is pretty useful.

She's not a loving, mushy person at all. She's kind of a solitary person—kind of closed off. I'm a home person, and she's a "let's get out of this home" person. She likes ballet and I like singing and acting. I'm an animal person. Juliana tolerates animals, but she doesn't love them like my mom and I do. She gets paid to babysit, and that kind of makes her older and more independent, but I hate it when she brags. I guess she has to go to college in a couple of years, and I'll be rid of her.

I missed her once or twice when she was away this summer, but I'll probably miss her more when she's at college. She's nicer when she's away.

When she's around, she has a lot of criticism to offer. That's her gift: "Here's my critical view on your life."

She wants to be taller. She's counting the inches.

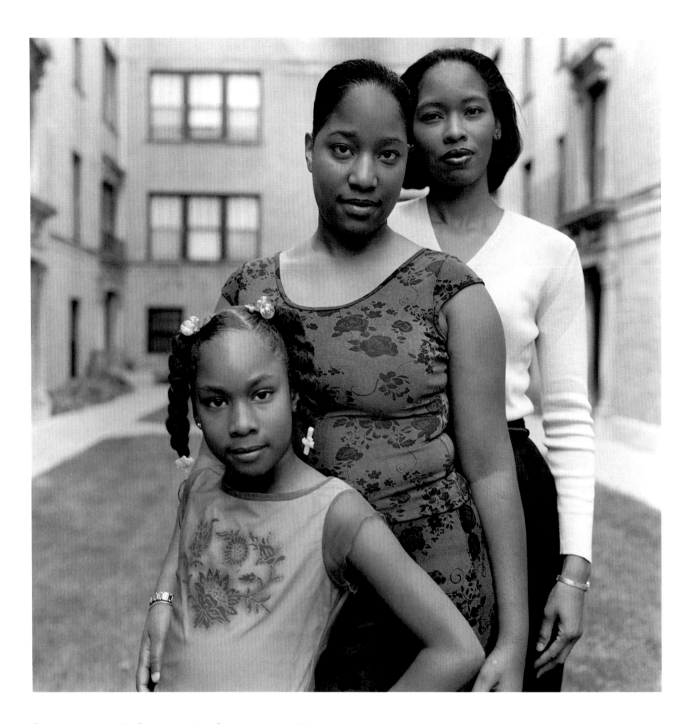

Shawniqua, age 10 Shana, age 21 Shawanda, age 27

shawanda
shana
shawniqua

Shawanda, age 27. We are five—three sisters and two brothers. Each sister has a different father. There are six years between me and Shana and seventeen between me and Nicki. I left home at 17, three months before Nicki was born, so she and I never lived together.

As a young girl, Shana wanted to be close to me and tried hard to impress me, but I stayed kind of distant. Nothing was ever good enough. Shana was nice, but I was clean. Our bedroom had two dimensions: clean and dirty. It bugged me when she'd stuff all her clothes and toys under the bed and then pull the cover down. I'd start to scold her, and she'd start singing a song called "You're My Sister." This song would make you cry, it was so sweet. Anytime I got mad, she'd sing.

I didn't see Shana much in high school because I was always gone. Beginning with ROTC at 5:30 a.m., I had school, band, and work until 10:30 p.m. Then I did home-work and cleaned. All I wanted to do after that was take a bath—not talk to Shana. When I left for college, I don't think I even said a proper goodbye. I'd do it differently now.

After I left, all the responsibility was thrown on Shana. My mother had become single, and Shana's life was like a teenage mother's. She couldn't enjoy high school be-cause she had too many responsibilities. When Shana was 18, my mother moved away. Shana stayed here, but she felt put out. The move was hard for Nicki, too. Shana did everything for her.

Shana wants to mend everything back together. She would give her last to anybody. When I had Mia, she came for six weeks. When I graduated from college, she brought balloons and flowers. Nicki is shy and to her-self—still unfolding. I'm known as the mean one because I say *no* to people. My siblings don't know how to accept *no*. They don't realize it teaches you independence.

The oldest sister should make a path and be a leader. I led, but there was no one behind me . . . my sis-ters weren't included, and I'm sorry for that. The only thing I can do is be a better sister from this day on.

Shana, age 21. Growing up, Shawanda and I didn't have much in common except sisterhood. Shawanda was the shining star. She was into academics, ROTC, and band and I was into running around outside. I wanted to shine, too, but when you're the middle, your presence is noted but not necessarily praised. You're expected to be either setting or following the example. There's no place for you to be on your own.

Shawanda was more a mother than an older sister. She was serious and strict. She had permission to disci-pline me, and my way of getting back at her was to tell stories on her. I was the baby then and anything I said went. Then my little brother came, and Mom started asking me what I did to start the fight.

When Shawanda was coming up, she got to go out without us. After my father left, Mom started working, and I had to babysit the younger ones. And no, I couldn't go out unless they went with me. Shawanda was busy all day. I was 16 when Shawanda went to college. I was kind of hurt that she was leaving, but on the other hand, I got my own room.

She and I have a different moral sense. A person ask-ing her for something has to have acceptable reasons. If you tell me you need it and I have it to give, I'll give it. Shawanda tells me that I'm very caring—so caring that I let people walk all over me.

Shawniqua reminds me of me, with Shawanda ways. Like me, she has attitude and she pouts. Like Shawanda, she's prissy and keeps a lot inside. She says I'm the nice sister and Shawanda is the mean sister, but that's be-cause I'll buy her virtually anything she asks me for. With Shawanda, you have to earn it.

It's easier now to be the middle sister. I still have to set an example for Nicki. And Shawanda and I can relate more because we're older. She's been through things. She can advise me without being critical. I'm so proud of Shawanda's accomplishments. She makes me want to do better.

When you're the middle, your presence is noted but not necessarily praised.

Our bedroom had two dimensions: clean and dirty.

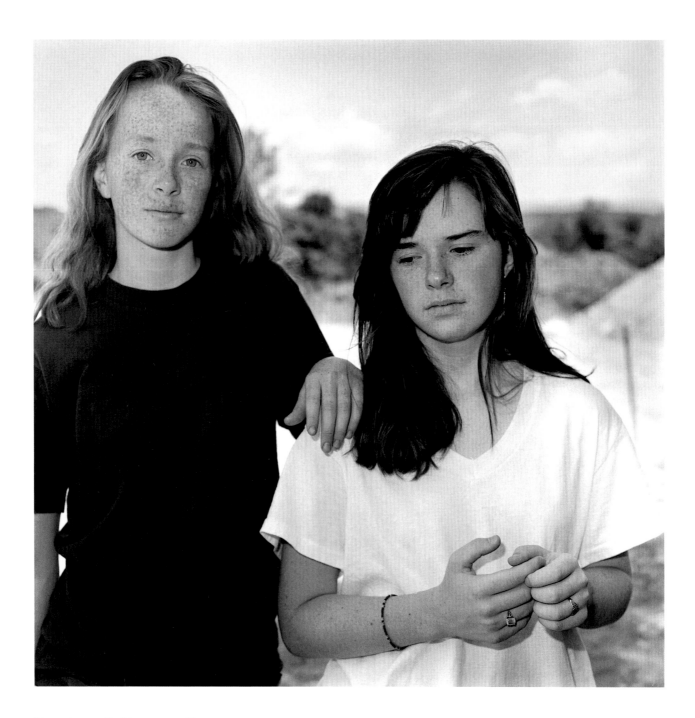

Hannah, age 14 Megan, age 16

hannah
megan

Megan, age 28. My mom told me that when Hannah first came home as an infant, all I wanted to do was hold her. Hannah was so beautiful and sweet. I wanted to protect her and keep her close to me. Now, she's truly my best friend. She's proven herself to me. Nobody can touch my sister.

When we were kids, we played and fought a lot. I was kind of a strange child. I read all the time, created elaborate art projects, built forts for imaginary friends or little animals that I found. I didn't have many friends. Hannah had tons. So I would just insert myself into her relationships. Hannah put up with it for a long time because I was too big to refuse. But there came a day when Hannah was 8 and she screamed at me to go to hell and leave her and her friends alone. Our entire dynamic changed in about two seconds. After that, she'd punch me back. It was good for her to set boundaries, but it was lonely for me.

We traded places in adolescence, which is about the time this picture was taken, Hannah didn't like me very much. I was immensely bitchy and self-involved. She was nerdy, shy, and frightened about a lot of things. She had just shot up and was towering over the boys. It was strange to watch because Hannah had always been strong and brave. I had followed *her* lead. I filled out physically at 14, and boys were expressing interest in me. She felt shunned by people. It must have been a really painful and awkward time for her.

When I went to college, Hannah realized suddenly how many things I protected her from at home. I was her first line of defense with my parents, mouthing off when they were red-faced and angry. In college, I lived in a completely private world that didn't have my parents in it. All kinds of smoking, drinking, and other illicit stuff would go on, yet they had no way of really penetrating it. I'm sure they dumped all their worries about me on Hannah. My world was sort of exciting to Hannah. She wanted to hang out with me more. We became friends.

I felt a tremendous amount of responsibility for helping Hannah in the girl department. I was the one who got her first lingerie, her first lipstick, her first makeup, who taught her how to kiss. I taught her how to use tampons.

Right after college, I was hospitalized. I was diagnosed with Crohn's disease. I had been sick since I was 17—suffering from terrible diarrhea and bleeding, which I had kept secret from my family and most of my friends. It was a horrible thing to talk about or admit, especially as a young woman. I was losing lots of weight. I couldn't sleep more than a couple of hours at a time, so I was incredibly irritable all the time. I didn't put it together that I was sick. Neither did anyone else. Finally, one of my dearest professors helped me to see that this was not normal, and I went into the hospital. They took me off food and put me on steroids and a whole parade of drugs. My face got huge from all the medications, while my body remained tiny and emaciated. I was exhausted and demoralized.

At the time, Hannah was kind of detached. She was in Florida working as a professional groom. As she saw me slowly recover, she became more concerned and loving towards me. We both became acutely aware of our limits. I think her seeing me get sick might have triggered something about her own mortality. I know I drove her nuts sometimes with emotional phone calls.

When I moved to L.A., a lot of really bad shit went down in my life. I think those years kind of broke me. Hannah was my only confidante at the time. She would let me talk about my situation in a way that nobody else would be able to listen to. She certainly didn't want me to do all the things I was doing, but she was supportive of me anyway. We almost never have problems between the two of us anymore. Of course, there are the inherent little annoyances, like when she'll roll out of bed at 7 a.m. and have a cigarette. And Hannah is a little more unwieldy than I am, and I always worry that something is going to get broken when she enters my space.

When I went to college, Hannah realized suddenly how many things I protected her from at home.

She is, at the cornerstone, a very courageous and centered person, and I do like the unwieldiness of her when it's not in my little tight world. I like that she's out in the world experiencing life in a way that I can't. She'll just meet people and not feel that her space is invaded. Sometimes she can't verbalize what she's feeling, but as a writer, she's incredibly expressive. She challenges me because she comes at life from a different point of view.

I think that Hannah and I both have a core fear of life, but we also have different ways of accepting that fear. I knit, draw, paint, and design fashion. I process fear and imbalance by creating order in small places. Hannah goes more with the flow of things. I have a memory of her riding a 3-year-old black horse when she was 14. The horse was barely broken. Her blond hair and his black hair were streaming out behind. The energy of the horse was just barely reigned in. Hannah was able to sit comfortably on the back of all that energy and direct it and feel it and move through it. That wildness always created so much anxiety for me. I organize and create life in my own way. Energy will move through me and come out of me expressed in a really concrete visual form like a sweater, a painting, a design. Hannah goes with the movement of life. The energy just seems to be her. The whole thing is about the process, and her struggle is that she doesn't see the one thing that she created, finished, and moved on from. With Hannah, it's not a sweater or a painting on the wall that you can look at and say, "Here's what exists"—it's Hannah herself.

I don't feel like the older sister anymore. There's no authority. I recognize that Hannah has a lot of wisdom to share with me. When I was growing up, I felt like the perpetual teacher. It's very hard to let go of that domineering role. In the past I have been insecure that I might not be important in our relationship if I wasn't the teacher. Now I know differently. She is truly my best friend, which is, of course, what my mother always said would happen once we grew up!

Hannah, age 26. There's a picture of Megan when she was 6 and I was 4. It's her birthday, and she's dressed up in her birthday outfit—pink, frilly dress, a bow in her hair. I'm wearing overalls without a shirt underneath. My hair is everywhere, and my face is smeared with dirt. That picture holds true even now. She has purses and high heels. I wear jeans and go without makeup. We're very different people, but at heart, where it counts, we're extremely similar.

When we were kids, Megan was always my protector. She'd kick the bullies on the playground if they tried to bother me. She was my companion. When we went on cross-country family vacations, I remember crawling up on Megan's back and having her carry me. She literally piggybacked me across the United States.

It started to change when I was around 12 and she was about 14 . . . high school. We moved into separate orbits. She was concentrating solely on being a teenager, which involved a great deal of butting heads with my parents. Megan was like a bull—head down to the ground, straining forward, ready to break out of the gate and go to college. It seems to me that she absorbed most of my parents' attention. She was the heat. She was always pushing for more privilege with the car, later curfews, and so on. I resented her for being the cause of tension in the family. What I didn't appreciate until she left was how much all that noise was sheltering me. The family focus on her was like a big umbrella that enabled me to do what I wanted. I had pretty much been living at a horse farm down the road, coming and going from home as I pleased. After she left, my parents looked around and said, "Wait a minute, don't you have a curfew?"

At that point, about the time this photograph was taken, the only times Megan and I were interacting was when we were fighting. At one point, we were working at the same café. She had the driver's license, so she was responsible for getting me there. One day I was late, as I always was, and she was threatening to leave without me. When I came outside to get in the car, she drove the car about ten feet down the driveway and then stopped. I ran up to get in, and she drove ten feet further and stopped. This went on again and again down our extremely long driveway. By the time she finally let me in the car, I was seeing red.

When I was in college, we switched roles, and I took care of her. Six weeks after graduating, she was diagnosed with Crohn's disease, an intestinal problem that she'll have for the rest of her life. It can result in severe dehydration and rapid weight loss. To manage the disease, she was supposed to minimize stress and change her whole diet. Megan had never been one to handle stress smoothly. Her illness had gone on undiagnosed for so long that she ended up in the hospital for a while. So there she was, newly graduated, trying to figure out what she was going to do with her life, surrounded by people she didn't know, *and* trying to contend with a really serious health issue. She was used to having a body that could go 24/7, and suddenly, she was completely exhausted by the smallest efforts. The medication made her bloated. It really messed with how she, as a young woman, related to the world. We'd talk on the phone late into the night, and I would just listen. When she moved to Boston to get a job, I helped her meet the few people I knew out there. If she was going through a particularly lonely period, I would try to make sure someone stopped by to see her. She had to quit her job and literally slow down at a much younger age than most people. That's when she started to knit.

Hannah goes with the movement of life. The energy just seems to be her.

Megan has always been really argumentative, so we always assumed she would grow up to be a lawyer. But she didn't. She's a knitwear/textile designer in Los Angeles. She's always been an extremely impatient person. I mean, I remember her trying to make a cake, out of a box, that flopped, and—furious—she threw the cake on the floor. Knitting takes incredible patience. The stuff she creates is amazing, complicated—so many different patterns, and painstaking. She never stops. She's always making something. If she's not actually knitting something, she's designing something. It's really remarkable to watch her come into this passion. And Los Angeles . . . pretty much everyone I know who has ever tried to live in L.A. has hated it, and somehow, it was different for Megan. She seems to have found inner peace in Tinseltown.

Recently, we've been able to relate on an even deeper level. I've had my own issues transitioning into adulthood. There have been some extremely difficult moments, and at times I, too, have been very sick. I didn't feel that I could share these problems with my parents, but Megan was always open to letting me talk to her about it. Megan allowed me to be a sick person. I knew that she would keep my confidences as I've kept hers. We've covered each other's backs for a long time. Just as Megan had to learn how to live with a physical disability and all its social repercussions, so have I had to grow up and change my life. She could just choose to make herself sick with stress or bad food, just as I could make myself sick by not confronting my own challenges. But we don't choose illness. And having made that choice, we both struggle with the next question, "How do I make this a happy life?" Megan is my guide.

There's a really deep sense of care between us. We will not hesitate to fight with each other, because we know at the end of the day that we're still sisters. The love is unquestionable. It lies in us knowing that neither one of us is going to leave each other; we're sisters for life. More than sisters by blood, we're sisters by understanding.

I have a great-uncle who took care of his sister when she was dying. They were both in their 70s. He was married and had a very full life, but he moved in with her to be with her until she died. When I was in college, I went down with my father and grandfather to visit them. I was sleeping in the living room one night, and I woke up at about three in the morning. I saw my Uncle Jack, without his shirt on, thousands of miles away from his own wife and kids and grandkids, gently helping my aunt into the bathroom to take care of whatever needed to be done. He emanated such grace, such active love for his sister. Witnessing that made me decide to be there for Megan, no matter what. I know she feels the same way. If there are problems and we are in need of each other, spouses or no spouses, we'll find a way to be together. It's the most important relationship in my life.

More than sisters by blood, we're sisters by understanding.

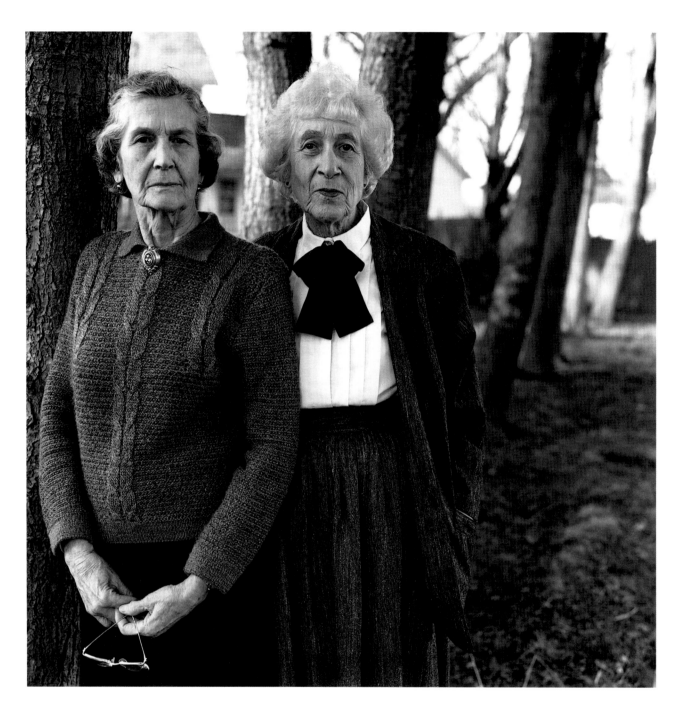

Lois, age 81 Auriel, age 87

auriel lois

Auriel, age 90. Lois and I lived together about fifty years. Lois has been in a nursing home with Alzheimer's since before Christmas 2001. My middle sister, Thelma, has Alzheimer's, too. She's down in Connecticut, so I don't get to see her. Now I have the house to myself, and I don't particularly like it at my age—90. It's no fun being dependent on others. I don't have a car, and I wouldn't be able to get a license if I wanted one. Most people are very nice, but you can't call on them too often. They don't have time to take care of old people like me. They have their own lives to live. I try not to complain too much, but it is difficult sometimes, having to pay other people to do things for you.

I'm the oldest and Lois is the youngest. Thelma is in the middle. I never really got along with Thelma. I think it all started when she was born on my birthday! I resented the fact that I had always been the big shot, and suddenly, there she was . . . on my birthday! Thelma's quite different from Lois and me, anyway. Lois and I like going to the theater. We like music and concerts and all that stuff. Thelma never liked that. My father always said she was his boy. She was always pulling all sorts of stunts and getting into trouble. I think the only person who Thelma ever really cared about was Edith. That was the girl she lived with. They both taught school. Thelma depended on Edith so much that when she died, Thelma didn't know what to do with herself.

I'm six years older than Lois. I was the one who left home, and Lois was the one who stayed. I was glad to get away from home. As the eldest, I had a lot of responsibility as a child. I felt the others got the attention and I was supposed to take care of everyone. I was glad to get away.

When Lois was in college, she was very attractive. She may not have made honors, but she never missed a dance. Lois was engaged to be married once, but my mother and the boy's mother didn't like the situation very well—one was Catholic and one was not. That was the one love of her life. My mother never encouraged her too much to go out with fellows. Lois was the baby, and my mother was depending on her. But Lois never quite had the courage to break away, either. Lois was dependent on my mother, too.

When I was 21, I got a job with the foreign service and went to Hong Kong. In leaving home, I discovered my own life. I could do what I wanted to do, how I wanted to do it, without having to ask. I discovered that I was important, too; I had my own life, my own friends, and my own way of living it. When the war came in 1943, I got transferred to Mexico City, where I met my husband. He and I went to Newfoundland during the war and then to Colombia, South America. After the war, we got assignments in Switzerland, Iran, and Africa. When I was 40, we came home. We needed a break. I didn't want to live in Tennessee with his family, and he didn't want to live in Massachusetts with mine. We had an arrangement that when the time came, he'd take his money and go to his family and I'd take mine. It was just one of those things. There were no bad feelings. I have very wonderful memories of my marriage, but it just wouldn't have worked out for the two of us to stay together. There were no children involved. He got another assignment in Vietnam, and I just couldn't face going off again. I was in my 40s. My mother wasn't well, and Lois had been stuck there with my mother; she couldn't even leave the house. She needed somebody. I just told my husband I was needed at home.

Mother had Alzheimer's, and she'd wander off. We hired somebody to watch her during the day while we worked at Smith College, and we took care of her at night. Lois is the one who really took care of her; she bathed her and saw that she was dressed properly. I just stayed home to allow Lois to get out of the house. Having been married, I wasn't interested in dating. If a man wanted to take me out to the theater, that was okay, but I wasn't very excited about going out anymore. I had gone beyond that stage. And Lois was much younger

[Lois] may not have made honors, but she never missed a dance.

107

and needed time for herself. She never married. I don't think she was as interested in marriage as she was in having a baby.

Lois took after my mother a lot. I had been away so long that I was far more independent than she was. We got along beautifully. Lois was a marvelous cook, and I hated cooking. She hated cleaning, so I cleaned. She had a car, and I helped pay for gasoline. She sewed our clothes. We were good for each other, and we got everything done. We took care of our mother for almost ten years.

After my mother died, Lois and I lived together in the house on Lily Street until it became too much for us, and then we bought this house; it's smaller, in a different neighborhood. Being the oldest, I thought I'd probably die first. Then a few years ago, Lois started with the Alzheimer's. She'd been going downhill for a while . . . well, not too bad . . . you could handle it. Then, all of a sudden, it just got much worse. She started to wander off. I'd turn my back and she'd be gone. They say that they're trying to find home and they don't know where home is, so they just wander. A couple of times I had to call the police because she'd be trying to get out of the house, and I was afraid she might knock me down. If I didn't drive with her, she'd drive on the sidewalk or the wrong way down a one-way street. One day, she accidentally hit me with the car, so she lost her license. I was trying to keep her driving just to have a car, but she should not have been driving. She stopped remembering how to dress herself. I'd get a bit bossy as I tried to do it for

I wish that Lois lived back home with me, if she were well enough. If there were any way, I'd have her home in a minute.

her, but she'd get mad and she wouldn't accept it. Eventually, I didn't have the strength to cope with it anymore.

The nursing home where Lois stays now is locked, and you have to have a key to get in and out. You don't have to worry about them getting out in the middle of the night and wandering off, and that's a relief for your mind. Up there, they bathe her, dress her, and make sure her hair is done—and she's happy. After supper, when they're all in that big room, they put the music on, and she'll wave her hands along with the music. She'll sing and sing . . . maybe dance a little.

I don't see her a lot because I have no way of getting up to the nursing home. My cousin takes me there every once in a while to give her a hug or sing to her. But frankly, she doesn't know who I am, anyway. That's the sad part. I miss her terribly. She looks well, though. She's probably going to live to be 100 up there.

I'm trying to clean out Lois's stuff here at home, but I'm very tired most of the time. If I sit down, I fall asleep. I have her picture in the living room, but it's lonesome in the house. I have a pussycat, but I miss having someone to talk to about the old days. Everybody says I should go to a nursing home, but I have to have my yard. My spirit is out there, and when I can get outside and pull up a weed, plant a plant, poke around, I'm all right. I'd be devastated in a nursing home. Without a yard, I think I'd die.

I wish that Lois lived back home with me, if she were well enough. If there were any way, I'd have her home in a minute.

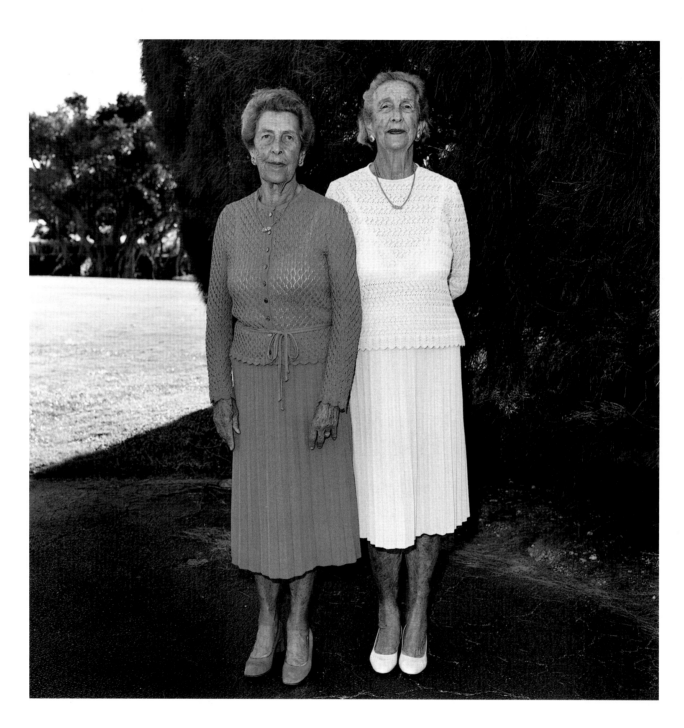

Ann, age 81 Jane, age 83

We have shown each other our best and our most
vulnerable sides—and stayed connected to tell the tales. **Susan**

Acknowledgments

First, I would like to thank all the sisters who so courageously and generously allowed me into their lives, not once but twice, and without whom this book would not have been possible.

I would also like to extend my thanks to Kat Falls, Carol Eckstein, Miram Kass, Diane Salk, Jane Samuelson, and Doug Baz for their encouragement, skillful edits, and thoughtful insights throughout the project. To Marta Bilodeau, who's been there since the beginning. To Kim Coventry for her astute sensibilities, tact, and tireless efforts to bring this book to fruition. To the gals at the Grillo Group for their fabulous design work. Many thanks to Sara Lasser, who recently earned a master's degree at the School of the Art Institute of Chicago, for her illuminating foreword. I am grateful for the generous support of the Barbara Deming Memorial Fund/Money for Women.

To Leigh Norton for loving my children so dearly while I was glued to my computer.

To my husband, Peter Power, for all of the above, but especially for love and time and making dinner. To Mom and Mac and Dad and Barbi, who had the good sense to give me many more sisters (and a brother). And finally, to my beloved sisters, Myra and Diana, and stepsister Bebe, who make my life infinitely richer.

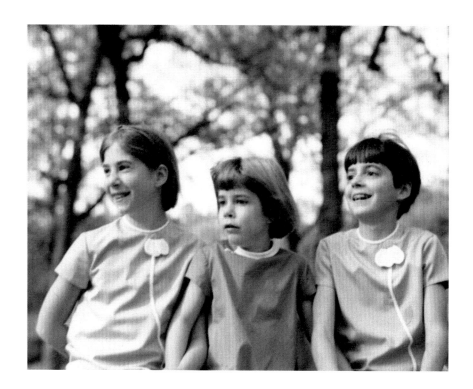

The Donnelley sisters in 1967: Diana, age 8 Deborah, age 4 Myra, age 9